INTERNET
for Artists
101
Second Edition

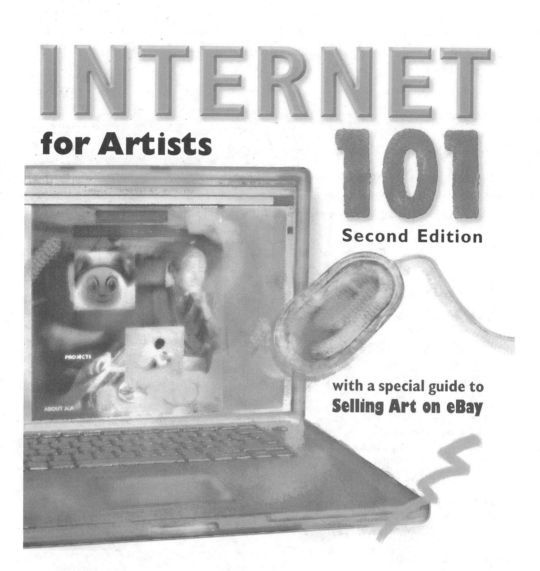

with a special guide to
Selling Art on eBay

BY CONSTANCE SMITH WITH SUSAN F GREAVES

Art
Network

Second Edition June 2007
Copyright 2007 by Constance Smith and Susan F Greaves
Cover and interior design by Laura Ottina Davis

Published by ArtNetwork, PO Box 1360, Nevada City, CA 95959-1360
(800) 383 0677 (530) 470 0862 (530) 470 0256 Fax
www.artmarketing.com <info@artmarketing.com>

ArtNetwork was created in 1986 with the idea of teaching fine artists how to earn a living from their creations. In addition to publishing business books, ArtNetwork also has a myriad of mailing lists—which we use to market our products—available for rent to artists and art world professionals. See our web site for details.

Susan F Greaves can be contacted at greavesart@aol.com or www.susanfgreaves.com.

Publisher's Cataloging in Publication

Smith, Constance, 1949

Internet 101 for the fine artist : with a special guide to
 selling art on ebay / by Constance Smith with
 Susan F Greaves. -- 2nd ed. -- Nevada City, CA : ArtNetwork, 2004.
 p. ; cm.
 (101 series)
 Available in print and as a PDF file via e-mail from the publisher.
 Includes index.
 ISBN: 0-940899-98-1
 13-digit ISBN 978 0-940899-98-8

 1. Art--Marketing. 2. Selling. 3. Internet marketing. 4. Internet.
 I. Greaves, Susan II. Title.

HF5415.1265 .S65 2004
658.8/72 --dc22 0401

Disclaimer: While the publisher and author have made every reasonable attempt to obtain accurate information and verify same, occasional address and telephone number changes are inevitable, as well as other discrepancies. We assume no liability for errors or omissions in editorial listings. Should you discover any changes, please write the publisher so that corrections may be made in future printings.

Printed and bound in the United States of America

Distributed to the trade in the United States by Consortium Book Sales and Distribution

FOREWORD

In 1995 an onslaught of TV, radio and print media hype occurred, all introducing the World Wide Web. The World Wide Web came of age. Many companies began investing thousands of dollars in building their web sites. Web-related professionals abounded. Investors brought out their checkbooks. Web businesses had their CEOs on the cover of *Time* magazine as "CEO of the year." Small-time investors, small-time inventors and small-time employees were made into millionaires practically overnight. This was the big boom time. People saw future fortunes and pursued them.

By 2000 the gold rush was over. Investors learned that long-term planning should be the prime factor in determining their investments. But not to fear. The Internet is still going super-strong. New ideas are popping up every day. "Why didn't I think of that?" is said by millions of people who participate in a new site. The Internet seems to have a creative urge of its own.

This book takes hours and hours to update. Much time is spent online to verify aspects and I learn an immense amount. Then, of course, I try to translate all I have learned into an easy-to-understand, readable package so you will not be overwhelmed by it all.

My favorite new site on the web is YouTube. How can anyone ever get bored with YouTube available 24/7? I just love to see these great amateurs (usually) create fantastic videos of what they do best: juggle, mime, dance, goof off, sing. It's a lot healthier and more educational to watch than most sitcoms and certainly much more fun than "American Idol."

The world of art has, undoubtedly, been affected by the World Wide Web, albeit perhaps more slowly than other commodities. Susan F Greaves' in-depth chapter about making sales on eBay will be of prime interest to artists. Follow her easy step-by-step instructions and you, too, may make what she made in one year: $30K plus.

My personal hope for the creative world (visual arts, poetry, literature) is that the Internet will enable those who might not otherwise have their voices heard. Perhaps, then, the art world will not be so controlled by the critics, historians and gallery owners, but more by popular interest. Perhaps the general public will become more educated about art, incorporating more art into their lives. Surely this would be a revolution.

Constance Smith

Table of Contents

Introduction

Knowledge empowers. Hopefully, this book will fill the gaps and correct the myths about art on the Internet.

For an artist, the web is a different marketing tool than for mass marketers. "How many hits does your site get a day?" is not as important a question for an artist as it is for Amazon.com. The important thing for artists is to get the *right* hits, the *right* people to visit their sites.

In writing this book, we wanted to create a user-friendly tool that would take artists, step-by-step, into a new mode of publicity, communication and promotion.

For whom is this book written?

Internet 101 is designed for the total novice as well as the slightly experienced.

The business of marketing art has become more and more sophisticated. To stay on top, an artist must continue to educate himself. This handbook will teach artists how the Internet can help their art career.

Fears, frustrations and preference for spending time creating art are reasons (but not good ones) that you may not learn to use the Internet to your advantage. Nevertheless, the Internet has become a fact of life. If your business doesn't have e-mail, you look archaic. If you don't have a web presence, people won't believe you're a serious career artist.

The Internet and change are synonymous. Keep updated on what's new by going back to your favorite bookmarked sites, subscribing to appropriate newsletters and searching out new information. Even as we were finishing this update, we had to add many sections as we found out about what's happening online. Learning about the Internet is truly a neverending process.

In this book you will learn:

▸ How to make money on eBay

▸ E-mail communication

▸ Creative tricks and shortcuts for using the Internet for research

▸ The advantages of having a home page on the web

▸ Basic design layouts for an artist's web site

▸ Basic promotional techniques for attracting clients to your site

▸ Creative ideas to enable you to sell art online

Everything we do reflects who we are. In most areas of our lives, the clarity of our goal has a direct relationship to the success that we achieve with it. This book is intended to help you create a clear goal in the area of marketing your fine art using the Internet as a tool.

How to use this book

Treat this book like a workbook. Conquer chapters one at a time. Most knowledge will build on itself. Fill in the blanks. Learn the lingo. Make notes throughout the book. Use the Action Plan at the end of each chapter to create your online marketing plan.

Designed after our best-selling book *Art Marketing 101*, the chapters are simple to read, with plenty of space to jot down notes. Write all over the margins, as it will help you to remember ideas. The detailed Table of Contents and Index make it easy to find the exact topic for which you are looking.

Do not browbeat yourself. Do not study and work on the Internet if you are in a stressed, frustrated, irritated or bad mood. It could take you to the brink! If you see yourself getting frustrated by slow downloads, losing information, or being unable to find what you want, shut down the computer and go back later. It's not worth the loss of your energy.

There is an entire new language you will have to learn. When you see a new word in the text of this book and need a definition, look in Chapter 1, pages 14-17. No need to memorize these definitions: Soon they will simply become part of your business vocabulary.

The listings in the resource section (Chapter 7) should not be interpreted as an endorsement. No advertising was accepted for this book. Due to the transitory nature of so many dot-com companies, some of the URLs listed might have changed or gone out of business by the time this publication reaches you. If you know of such an occurrence, we would appreciate it if you e-mail any corrections to us at <info@artmarketing.com>. Please note "Internet 101 update" in the subject line of your e-mail.

URL listings

▸ Within a list, web sites are listed without the "www" in front. The savvy way to tell someone a web site address in person or on the phone is to say the URL dot com (or dot org, etc.): i.e., "We are located at artmarketing.com." There is no need any longer to say the www in front of the URL; in fact, it sounds inexperienced.

▸ Within a list, we have also eliminated the ".com" unless it is other than .com, such as .org, .co.uk, etc.

▸ We have added the ".com" ending and "www" beginning when we use the URL within a sentence. This is the proper way to format a URL when writing.

▸ The proper way to list a URL in a printed document is without the "http://" in front of it: www. artmarketing.com is all you list. Http:// is only used online. Http:// stands for hyper link, and that is what it does—it links you to the site. Since you cannot link from the printed page, it's not necessary. An exception is a scholarly citation, in which case you should use the entire URL, including "http://."

If you have any topics you would like covered in future editions, or any questions about something covered here, please let us know at info@artmarketing.com.

Have a blast—stay on track. Explore to your heart's content!

Chapter 1
Basics of the Internet

A little history

Equipment

Lingo

Before every new form there is a period of chaos.

A LITTLE HISTORY

The Internet was developed in the late '60s for the military's use. This system assured that, providing the phone lines didn't collapse, people would be able to communicate with each other in the event of a catastrophe. Computers were large, expensive and difficult to use in those days.

Small personal computers were not developed until the mid-'70s. During this same period, what had first been called Arpanet began to be called Internet, with links from the US to Britain and Norway.

Realizing the potential for communication among all people via their personal computers, some savvy engineers began to experiment, eventually coming up with a huge computer network called the World Wide Web, aka WWW. This WWW was invented in 1989 at CERN in Geneva, the greatest European physics lab. Only after that did the Internet become popular outside universities and research centers.

In 1993, Marc Andressen, a 23-year-old student at the University of Illinois and founder of Netscape, invented Mosaic, the first browser able to visualize images in web documents. Soon, all kinds of businesses were interested in exploiting this new resource. Some say it was a phenomenon similar to the Gold Rush in California.

History continues today—with web music, webcasts, blogs, MySpace, YouTube and more.

EQUIPMENT

Whether or not you ultimately decide to expose your artwork on the Internet, as an entrepreneur you will need to know how to use a computer, receive and send e-mail and browse the web. You must become computer-literate to that degree—not a whiz-kid, but literate enough to know how to type and print out a letter, access the Internet, and send e-mail. Additionally, knowledge of graphic programs (for example, Photoshop) will save you tons of money during your fine-art career. The more you know, the better off you will be.

You will need to invest in a variety of machines that help you accomplish your business tasks. Start with the right tools and make your climb to success easier. If you don't wish to invest in these tools (or feel you can't), it will be a great hindrance and most likely will slow your progress considerably.

COMPUTERS

If you already own a computer, great. If you are unfamiliar with computers and don't know how to choose one, an introduction is in order. Perhaps an introductory course at a local college would be a good route to take.

There are two computer systems available: PC (personal computers such as Compaq, IBM, Gateway) and Macintosh (Apple Corporation makes iMac and other such models). The two groups of computers recently have become quite a bit more compatible: Both now use a USB cable, and data and text can be interchanged between these two types of computers via a diskette, CD or the web.

Most creatively-oriented people (i.e., artists, designers, musicians) use the Macintosh system. Retail stores such as CompUSA and others are offering Macs at low prices ($795+). We use the Mac for our entire publishing business: books, accounting, Internet, data entry and more.

Macs are more innovative, trendy, stylish; PCs are usually less expensive (with many clone models available) and usually have more software programs available. With the advent of Windows, both systems are very user-friendly.

Since this is not a computer course but an introduction to using the Internet, we will not deal with computer basics here.

MODEMS

A modem is a device that connects your telephone line to the WWW and transmits computer data. These days a modem is generally built directly into the computer. Modems come in different "speeds"—28,000 to 56,000 bits per second.

DSL/DIRECT SERVICE LINE

Available in many locations nationwide, a DSL line connects you to the WWW at over 100 times faster than the fastest dial-up telephone modem. If you are a

heavy user of the Internet, this is the way to go. If you are a heavy user of e-mail, it is not necessary to buy this service. It costs about $35 per month plus an initial equipment fee of $100. For now, start with the basics; consider a DSL line for a future investment. You can always upgrade.

You can use your regular home telephone line for your Internet connection. Many phone companies offer to make your one-line system into a two-line system—one for your Internet connection, and one to answer telephone calls. Phone your local telephone company for particulars in your area.

In many areas you can now get Cable Internet or Satellite Dish Internet. Check in your area to see what is available.

PRINTERS

Ultimately, if you have a computer, you will need a printer. Dot-matrix or ink-jet color printers are inexpensive these days. Most of the expense comes with the cost of ink cartridges. Some printer models come equipped with fax and photocopier and even scanner.

ONLINE IMAGE FORMAT

Many of you probably have your work in slide format. These slides will need to be put into a digital format to upload onto the Internet. Professional scanners, such as the ones used by large pre-press service bureaus, offer the best quality of high-resolution output and color fidelity. Images scanned on smaller scanners usually need some reworking with a photo imaging program such as PhotoShop to correct or adjust colors and contrast.

If you want to scan slides at home, you will have to invest in a slide scanner. You can scan photos on less expensive "flatbed" scanners. Some flatbed scanners also have an attachment to scan slides. Service bureaus such as Kinkos (or your local copy house) can take a slide or print of your work and create a digital file for a nominal fee—usually about $5-10.

 If your work is not on a slide, the artwork itself, if it is small, will need to be scanned or a digital photograph will need to be taken in order to display it on the Internet.

TIPS

→ Have scans made to 300dpi (dots per inch) resolution. From this 300dpi scan, you will be able to create a 72dpi jpg (a type of digital image) for your web site and keep the 300dpi image if you need to print it on paper. If you ever work with a publisher or licensor, they will want this higher-resolution 300dpi format.

→ You might need a CD drive on your computer in order to transfer these large scanned files to whomever will need them, as they are usually too large to send via e-mail. The 72dpi jpgs are easily sent via e-mail.

DIGITAL CAMERAS

Most digital cameras' output quality exceeds the needs of the web. If you have a digital camera and are a good photographer, this might be the best way to get your artwork onto the Internet.

TIP

There are companies online that will print your photos for as little as 12¢ and send them to you—much easier than going to your local developer. Try www.snap.com.

RESOURCES

Visual Horizons
180 Metro Park, Rochester, NY 14623 (800) 424 1011
www.storesmart.com
They scan slides and photo prints. Call or go online for prices and brochure.

ADG Printing
19231 36th Ave W #D, Lynnwood, WA 98036 (800) 342 3282
(425) 771 7603 ext 16 www.adgprinting.com
They can scan slides or even large-scale originals. They print all kinds of items to help you promote your art.

LINGO

This glossary has been put in the first chapter so you can acquaint yourself with these terms right away. You can refer back to these pages when necessary. Soon you will remember all the definitions. You will find some more definitions throughout the chapters (they have not been repeated here).

404 error - pops up online when a link doesn't work online

Address book - stores all your e-mail addresses in categories within your e-mail software

Attachment - a file that comes via an e-mail. It can be an image, text, music, advertisement, invoice, etc.

Banner - an ad on a web site, often containing the logo of the advertiser with a link to their site

BBS - an online bulletin board system; this allows users to hold discussions and make announcements that others can then read and respond to

BCC/Blind carbon copy - a way to send e-mail to several people at once without them seeing the addresses of the other recipients

Bit - the smallest unit of memory (a combo of binary and digit)

Blog - a web site, somewhat like a diary or daily record, containing information the owner of the web site wants to write about, usually on a particular topic of interest

Bookmark - a way to save the address of a web site with your browser program so that it is easy to find later

Browser - a software program, such as Explorer or Netscape, that enables you to navigate the Internet

Cache - a page you've opened on the Internet that is automatically stored in your computer

CGI/Common Gateway Interface - programming protocol for interactive sites that have guest books, order forms, etc.

Chat room - an area in an online service where several users can "talk" simultaneously and exchange messages

Cookie - data that is placed in your computer when you visit a site. The site that you visited can then trace your activities: what you buy, where you browse, etc. Many sites you visit on the WWW will deposit invisible cookies onto your computer, allowing them to identify you when you return. Cookies can be invasive. To see how cookies work, visit www.privacy.net, a consumer-protection site. To learn how to view, manage and delete cookies, visit www.cookiecentral.com.

Crawler - Similar to a spider, this is a program that searches the Internet in an attempt to find resources.

Cyber gallery - a place where artwork from several artists is displayed online

Dial-up connection - a connection to the Internet using a telephone line

Discussion group - an electronic message board that contains notes focusing on a specific topic

Domain name - an Internet address or home page

Download - the process of placing files from the web onto your computer

DPI - dots per inch. All computer screens have a resolution of 72dpi.

E-mail - acronym for electronic mail, a method of communication via the Internet

Ezine - an online magazine

FAQ - Frequently Asked Questions; you'll find this link on many sites so they don't have to answer the same questions over and over via e-mail.

Font - a typeface used in text layout

Forum - a discussion group online

FTP/File Transfer Protocol - a program that allows you to upload and download data onto the Internet

GIF/Graphic Interchange Format - a graphic format for the Internet used mostly for items other than fine art

Hit - Each time a visitor clicks on a web page or image, it is counted as a hit.

Home page - the first page of a web site

Host - a company that gives you space online to store your web site

HTML/Hyper Text Markup Language - the coding language used to create web pages for use on the Internet. In most cases the general public, or even you, an artist with a web page, will never have to learn this coding language to publish a page on the Internet or to browse the Internet.

HTTP/Hyper Text Transfer Protocol - the system of communication on the Internet that enables links to work

Hyper text link - text that enables you to click on it and link to another place on the Internet (usually <u>underlined</u> on the computer screen)

Internet - computer networks that are connected via the massive worldwide electronic network

ISP/Internet Service Provider - a company that provides Internet access to customers. AOL is the most commonly known ISP in the US.

JPG/JPEG/Joint Photographic Experts Group (pronounced jay-peg) - acronym for a graphics format that is generally used for fine art displayed on the Internet. By definition a jpg is 72dpi.

Junk mail - unwanted solicitations by e-mail

Keyword - "hidden" words used to help a search engine identify your web page

Link - a connection between two places on the Internet

Menu bar - usually on the top or left side of a web site; shows the various areas on the site you can link to; same as Navigation bar or Scroll bar

Meta tags - keywords that a web designer encodes into a page. Search engines use these words to index the web site.

Modem - a computer device that connects to a phone line and allows communication between computers and the WWW

Navigation bar - same as Menu bar or Scroll bar

Net - short for Internet

Newbie - someone new to the online world

Newsgroup - an online message board that focuses on a particular subject

Online - connected to the Internet

Page - the basic unit of which a web site is made

Page header - the design at the top of an Internet page; often the company's logo

Password - a combination of letters or numbers known only by the user, which allows access to secured areas of the Internet

PDF/Portable Document Format - a computer format that saves a document in page layout form and is readable by Acrobat Reader, a software program available free at www.adobe.com

Peripheral - an electronic device that is used by your computer but not contained within its hardware (for example, an external modem)

Post - upload data onto a web site; also called publish

Proprietary server - a large ISP server such as AOL, Prodigy, CompuServe

Publish - upload data onto a web site; also called post

Scroll bar - usually on the top or left side of a web site; shows the various areas on the site you can link to; same as Menu bar or Navigation bar

Search engine - a web site that searches the Internet for requested information using a suggested keyword or phrase; Yahoo, Google, Alta Vista are examples.

Secured site - It takes a secret code to enter this site, thus protecting transfer of credit card data or other confidential information.

Signature - a block of information used to sign the end of an e-mail; usually includes name, company name and other important information.

Site map - an outline of sections of a web site. An example is on page 54. Designed to help the consumer find items more easily on a given site.

SMTP/Simple Mail Transfer Protocol - guides the transmission of electronic mail through the Internet. You might notice this acronym when setting up your e-mail account.

Snail mail - United States Post Office mail, i.e., slow mail

Software - a program that runs some functions of your computer

Spam - unwanted and unsolicited e-mail

Spider - search engine device that crawls through web sites to gather information

Splash page - the entryway into your web site; often has flashes, music, and other bells and whistles taking extra time to download; often irritating to visitors!

Surfer - a person browsing the Net; also called a visitor

Thumbnail - a small version of a picture on a web site that links to a larger version

TIFF/Tagged Image File Format - used for artwork that is not shown on the web; 300dpi; usually used for printing purposes

Traffic - the number of visitors to your web site

Upgrade - the newest version of a software program

Upload - the process of sending files onto the Internet

URL/Uniform Resource Locator - the address for an Internet user; for example, ArtNetwork's URL is artmarketing.com.

Virus - a destructive program that is usually transferred over a modem or diskette and infects parts of a computer system, causing it to crash, malfunction or lose data

Visitor - a person browsing the Net; also called a surfer

Watermark - digital watermark that imprints a copyright message on images; visible when printed, imperceptible on-screen, traceable on the Internet

Web designer - author or designer of web pages (see page 60)

Web marketing consultant - versed in marketing and advertising on the web

World Wide Web/WWW - the rules, procedures and programs allowing files to travel across the Internet and creating links of words, pictures and sounds

Web server - the storage area for files and programs that constitute a site

Zine - an electronic publication

ACTION PLAN

❑ Buy a computer.

❑ Learn how to use the computer.

❑ Get DSL, satellite or cable Internet connection.

❑ Start using the lingo of the Internet.

RECOMMENDED READING

A Few Scanning Tips by Wayne Fulton

Internet 101 for Dummies by John Levine

Netlaw: Your Rights in the Online World by Lane Rose

Chapter 2
You've Got E-Mail

Setting up e-mail

Sending and receiving e-mail

Doing business via e-mail

Broadcasting

Marketingartist.com

The medium is the message.
Marshall McCluen

SETTING UP E-MAIL

In order to use e-mail, you must first subscribe to an Internet Service Provider.

INTERNET SERVICE PROVIDER/ISP

An Internet Service Provider, sometimes called an ISP, has a big computer that allows users to store information, sort of like a post office box. ISPs abound in every city. You've probably seen large signage all over your own town advertising them. For a fee of $9-20 per month, an ISP will give you a local telephone number (sometimes an 800 number) to dial via your computer modem and connect to the Internet. (With a cable or dish connection, you won't use a telephone number).

Your ISP will ask you to choose an e-mail address. The address will look like this:

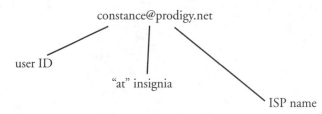

All e-mail addresses have an "@" separating the user ID and ISP name.

Your ISP also will give you the necessary computer software and instructions to connect to the Internet. Once you've installed that software, you're just a click away from sending an e-mail message.

CHOOSING YOUR E-MAIL ADDRESS

Choosing an appropriate e-mail address is important. Have your address be your first name, last name, first and last name, first initial and last name, company name or some description of your art style. If the name you choose matches your real name or your company name, it is much easier for people to remember. Keep your address short and simple: Don't use dots or periods, dashes or slashes, commas, underlines or numbers. No unusual spaces, capitals or characters. It should be easy to spell and remember.

▸ If you haven't used a middle initial in the past, don't start using it in your e-mail address.

▸ If you normally use a nickname, use that in your e-mail address.

ftc.com – Federal Trade Commission Consumer guide provides information on how to avoid e-mail scam. Search under Inventions for an article called Spotting Sweet-Sounding Promiese of Fraudulent Invention

GOOD ADDRESSES

constance@prodigy.net

constancesmith@prodigy.net

csmith@prodigy.net

artnetwork@prodigy.net

artmarketing@prodigy.net

BAD ADDRESSES

c@prodigy.net

ConstanceSmith@prodigy.net

blond@prodigy.net

artnet@prodigy.net

art-marketing@prodigy.net

Put your e-mail address on all of your promotional materials: letterhead, business card, ads, flyers, etc.

COMMON E-MAIL ADDRESS

Many companies use the word "info" or the employee's first name in front of their URL to create their e-mail address: info@artmarketing.com or connie@artmarketing.com. This reiterates the URL, engraving it into the customer's memory, and hopefully is simple enough to type.

FREE E-MAIL ACCOUNTS

You can also get a free e-mail account from various online companies: Hotmail, Yahoo, etc. You will still need an ISP to access the Internet.

WATCH FOR SCAMS

Don't even open e-mail that you know is "scam-infested." Artists seem to be particularly vulnerable to Nigerian scam e-mails. Most often you can tell by the way it is worded (the English is pretty poor) or simply their approach. Assume that anything that looks like a scam, is. Here is one I received recently: note the capitalization, spacing with periods and commas, capitalization of name and subject line (such as "chashier check," mispelled). All pretty horrendous!

> From: philscott_info@yahoo.com
> Subject: ARTWORK ORDER....
> Date: February 3, 2007 5:04:01 AM PST
> To: ade@yahoo.com
> Reply-To: philscott_info@yahoo.com
> Hello,
> my name is PHIL SCOTT , i will like to order for a piece of yourart work
> from your gallery as gift for my parent who are celebrating thier 30th wedding
> annivasarys , so i will be gald to have your reply asap, i will be glad if you can
> send me your website address to chooseor send me four of your product that is
> availble for me to choose . payment will be make by a chashier cheque.
> Waiting to read from you today.
> thanks
> PHIL

SENDING AND RECEIVING E-MAIL

Before you're able to send e-mail, you will need some "browser software" (not the same software you received from your ISP). Browser software is a computer program that enables you to read e-mail. It also enables you to store and sort e-mail and often comes with an address book. Most new computers come installed with browser software: Outlook Express, Netscape, etc. Newer Macs come with something simply called Mail. If you don't have a newer computer, you may need to purchase a browser software program from your local computer store. Usually they cost no more than $19.95.

But how do you know what browser you prefer if you've never used one? Ask your friends. See what their recommendations are.

Read the user manual that comes with your new browser software. It will teach you everything you need to know. With your browser software program open, the manual can be accessed on your computer. Pull down the "Help" tool at the top of your navigator bar. Under "Help" you will find an index of topics to choose from. You will be able to print our or read the info on your computer screen.

Set a goal regarding installing and learning your new browser software. Give yourself enough time. A two- or three-hour timeframe for installation and familiarization ought to be enough.

Your browser software manual will tell you:

▸ How to set up your e-mail

▸ How to send a friend or business associate an e-mail

▸ How to send a group of people the same e-mail with one click

▸ How to download e-mail

▸ How to save names to an address book

▸ How to send BCCs and what they are

The e-mail you send to a friend or business sits in a virtual bin until the person downloads it onto his own computer. He can open his individual pieces of e-mail at his convenience.

▸ You can save or trash e-mail.

▸ You can forward copies of e-mails to other people.

▸ You can copy contents of e-mails to other software programs, such as word processors.

▸ You can print out your e-mail as a hard copy.

▸ You can click on the sender's address and save it to your address book.

AUTOMATIC SIGNATURES

In most e-mail systems, you can set up your e-mail to automatically "sign" your name. To set up your automatic signature, consult your browser manual. An automatic signature can include your name and/or a quote, and/or a link to your web site. Keep it short and memorable.

A sample automatic signature could look like this:

Visit http://artmarketing.com for all your art marketing needs

By clicking on the underlined portion, the reader will be linked to that site on the Internet.

If you send out a particular note to people often—a subscription reminder, a monthly invoice, a reminder notice—you can format that in the signature part of your e-mail program as well.

E-MAILING A SAMPLE OF YOUR ARTWORK

To send an image of your artwork via e-mail to a prospective client, you will first need to transfer the image into a 'jpg' format. Detailed information about creating a jpg can be found in Chapter 5, page 58.

TIPS

→ If you want an associate or friend to open a specific URL, type in "http" before the URL: i.e., http://artmarketing.com. If they are connected to the Internet they just click on the underlined portion in your e-mail and it will link them to that URL.

→ You can type e-mail messages when you are off-line (not connected to the Internet). Save them by clicking the top left square on the message box and choosing the "Save" option on the menu. This will put the message into your draft folder. When you go back online, you can open the messages in your draft folder and send your e-mail.

→ Most browser programs allow you to type the first few letters of a name in the "To" box, and the browser will fill in the rest of the address (if you have saved it in your e-mail address book). If there are several "Michaels" in your e-mail address book, then the browser will pull up a list of Michaels to choose from. Click on the correct one and send.

→ To reply to an e-mail message someone has sent you, hit "Reply"; a new screen pops up with the sender's address in the outgoing slot. Just type in your reply and hit "Send." If your software is set up appropriately, it will also return the original e-mail script to the recipient, so the person will know to what you have replied!

Present yourself as the artist you want to be, whether you've reached your goal or not.

JUNK MAIL

The downside to e-mail is the infamous junk mail that you will receive. If you are receiving a lot of junk mail, ask your server if they have a program for editing it. Often, junk-mail remover software is embedded in the program you use for your e-mail. Check under "Tools," "Help," "Spam" or "Filters" for this information.

SUBJECT LINE

The subject line is a key aspect of an e-mail. Many users don't understand this. Study what subject lines you receive and how you respond to them. If you do that, you will know what to put in your subject line, whether for business or personal messages.

- Our spam filter deletes all e-mails that have no content in the subject line (and rightly so, as 99% of them are junk).

- Using "Hello," "Hi" is not a good business subject line. It might be fine to your sister or friend: They will recognize your e-mail address and not dump the message into the trash, but newcomers won't.

- Don't let the broadcast subject line appear to be junk mail. Choose a subject line that the receiver will respond to by opening it.

- It must be a subject line that is pertinent to content. Directness often works the best: "Meet Jay Sampson at his opening Friday the 15th of April."

- Never have a subject line in all caps.

- Asking a question is often a good subject line: "How can you improve your emotional life?" (By purchasing your painting, of course!)

- Create a teaser: "Meet the director of 'My Maison.'" (He happens to be your brother and is attending the event.)

GOOD SUBJECT LINES	BAD SUBJECT LINES
Artist exhibition	Win $3K
International art exhibition	Info
Living artist news	Better than ever
Local gallery event	Hello

TIPS

→ Be sure to use BCC/blind carbon copy when sending to several people. If you don't use BCC, then all the e-mail addresses will be viewable to all the recipients!

→ It can take six to eight e-mail contacts before someone starts to recognize your name and message. Consistency and persistence work best.

→ Make it easy for the recipient of your communication to arrive at your web site/URL. Your automatic signature should take care of this with a link.

→ Keep e-mails short and direct.

If you have e-mailed to an address that doesn't exist, your e-mail will be returned to you saying "Domain Unknown" or some other error message. You will see that either you have typed the address incorrectly or perhaps the person has changed his address, so you will need to delete it from your address book.

DOWNLOADING

Downloading is the process of copying a document onto your computer from the Internet or an e-mail. Never download a document or attachment unless you know who has sent it, as viruses can enter your computer system in this manner.

ATTACHMENTS

You can "attach" a document or jpg (picture of your artwork) to an e-mail by clicking on the "attachment" icon in the navigator bar of your browser and linking it to the jpg.

TIPS

→ Check your e-mail daily. It is the professional thing to do.

→ Try to respond to e-mails promptly.

→ You can retrieve old e-mails from the "Trash" or "Sent" file if you have not permanently deleted them. These files can be sorted by date, subject, sender, etc.

→ Use a spell checker on all your e-mails.

E-MAIL ABBREVIATIONS

FCFS - first come first served	PPD - postage paid
EOM - end of message	BTW - by the way
BRB - be right back	NRN - no reply necessary
TMI - too much information	LOL - laughing out loud
IMC - to whom it may concern	IMO - in my opinion
ROTFL - rolling on the floor laughing	FYI - for your information

Auto responder is an e-mail that automatically replies to an incoming e-mail, stating that you are out of the office for a period of time and cannot respond immediately.

For further definitions go to www.netlingo.com.

:-) = happy (smiley face)
:-(= sad (frown face)
:-0 = surprise
;-) = wink
:-p = tongue sticking out
:-} = an embarrassed smile

DOING BUSINESS VIA E-MAIL

Collection of potential client names and e-mail addresses should be a primary concern. That's why you'll want to start an e-mail address book of clients or patrons. Any individual collector or business sending you a message is worthy of recontacting.

ADDRESS BOOKS

As people start communicating with you via e-mail, you can save their addresses and create a mailing list or "address book." Create various categories to store your e-mail addresses. As an artist, you would have a list for your personal use (friends, relatives, tennis buddies, etc.), and one for your business (consultants, gallery owners, interior designers, publishers, suppliers, art stores, etc.). Your software manual will explain how to save an e-mail address into an address book.

GATHERING NAMES

Add names to your address book of art world professionals whom you've found through your research in magazines, online and elsewhere.

THE LOOK OF MESSAGES

Just because a message looks good when you click "send" doesn't mean the format will look the same when it is received on someone else's computer.

To minimize odd-looking e-mails:

- Avoid italic type.
- Keep lines no longer than 55-60 characters.
- If you are sending multiple addresses, use BCCs (see Chapter 1 definitions).
- Send a sample copy to your own computer and check out spelling, links, etc., before broadcasting to your in-house list.

PHISHING

This is the term for fraudulent e-mail that tricks a naive individual into giving away personal information. Phishers have become so adept that they can even trick the wisest of users. The e-mail can appear to come from your bank, PayPal or eBay, asking for an update on certain data, perhaps through a link.

The simple solution is never to give any personal data over the Internet. You can also check the FBI's scam alert site at www.fbi.gov/cyberinvest/escams.htm.

Phish e-mails typically don't have the recipient's name in the greeting, but usually have "eBay user," "PayPal user," etc. They often have typos too: "Our records indicates..."

6:1 rule
It takes six times as many dollars to bring in a new customer as it does to retain a current one.

80:20 rule
20% of your customers make up 80% of your business.

Evite.com is a web site that enables sending online invitations to events.

BROADCASTING

Broadcasting is the act of sending out a large quantity of e-mail all at the same time to your list of customers.

Did you know that you can send the same message to all the people in your address book with one click? A message that you send to multiple e-mail addresses is called a "broadcast." It is one more way for your artwork to reach potential clients.

Inform your patrons of upcoming shows, tell them about new artwork (including a picture of your work), wish them a happy holiday, etc. Be creative, inspirational, personal and mysterious. You'll have them hooked. When you finally meet this e-mail client at an opening reception you have in town, you will have a special connection.

▸ You should send a broadcast no more than every four weeks.

▸ Create messages that will intrigue your clients.

▸ Make the message your "poem."

▸ Spend some discretionary time composing your broadcast.

▸ Do you love to critique movies or novels? Clients might like to hear an artist's view of a movie they were considering watching.

▸ Do you have information that would help an emerging collector make better purchase choices?

▸ Have you visited an art museum that your client might like to travel to? You could review it and give your impression.

Find some good information on another site? Ask them if you can send an e-mail to your patrons linking them to that article, with a small teaser in your broadcast. In the same light, you can ask them if you can publish it directly on your site, with a link to their site.

Your broadcast should include:

▸ A link to your URL. Make sure it links properly: Send it to yourself and check the link.

▸ A photo of yourself or your artwork

▸ A message that is brief and easy to read

▸ A subject line that is distinct and doesn't read like junk mail

▸ A notice to unsubscribe if desired

Unsubscribe notice

NOTICE: If you no longer wish to receive e-mail updates, please hit reply and type REMOVE FROM LIST in subject line. If you have already requested that your name be removed from the list, please excuse our oversight as we update our list. Thank you. <info@artmarketing.com> http://artmarketing.com

If you keep your e-mail fun, informative and lively, your recipient will be hungry for future messages.

SUBJECT LINE

Per usual, the subject line is of utmost importance. If it intrigues receivers, they will open it. See page 24 for more information.

MANAGING YOUR E-MAIL LIST OF PATRONS

List management can be entirely automated. Your site should be gathering signatures from your guestbook and compiling them automatically. You should also be able to add, manually, to this list at any time.

One online company that can help you send to and automatically update your list is www.constantcontact.com. Usually you prepare the info, and you pay them to format it (or you can do this yourself), they send it out for you and their software automatically updates it. You can also ask your ISP or web master which might be the most effective way for you to do this.

SAMPLE INVITATION BROADCAST

Subject line: Art Reception 10/3

Celebrate with me during Friday night gallery walk on 10/3, 5-8 PM at Sudden Images, 3638 SW 12th Ave, Seattle.

I will be the featured artist at my first solo show, entitled "Magic in the Air" (here you link to the gallery site).

Because you are a previous patron, I would love to have your support and encouragement as my career progresses.

New prints will be available as well as 20 new originals on canvas.

Sandy Kolman (a link to your web site)

Directions (a link to a map and directions)

Unsubscribe notice
If you'd prefer to be taken off my invitation list, please return this e-mail with "remove" in the subject line and I'll do so immediately. This list is my private list and I do not share it with anyone.

MARKETINGARTIST.COM

www.marketingartist.com is an online program that will help get your business records in order and keep you on top of communications with clients. It is free so long as you don't use it in excess of their minimum requirements. As your business grows, you might need to use more space; if so, your fee will be $4.95 per month. This online site can help you:

▸ maintain a calendar of appointments with reminder beeps

▸ remember telephone calls to make

▸ keep track of daily and weekly to-do's, upcoming appointments and events

▸ organize client contacts, both e-mail and snail mail addresses, and print out mailing labels from your contact list

▸ keep track of each of your artworks, its historical data, what shows it's been in, what gallery has it on consignment at the moment, etc., and

▸ send e-mail to people about your upcoming art shows.

ACTION PLAN

- ❑ Sign up with an ISP.

- ❑ If your computer did not come with it, buy browser software and read the manual.

- ❑ Decide on a good e-mail address.

- ❑ Install a signature in your e-mail program.

- ❑ E-mail a friend.

- ❑ Notify business associates of your new e-mail address.

- ❑ Start compiling address books by collecting e-mail addresses of various art world professionals from ads in magazines or by researching online.

- ❑ Create an e-mail for a broadcast.

- ❑ Broadcast and keep track of the results.

- ❑ Explore www.marketingartist.com.

- ❑ Add your e-mail address to your letterhead, as well as to any literature and Yellow Page ads.

- ❑ Send a discount coupon to your clients via e-mail.

Chapter 3
Surfing the Web

RESEARCH

PEOPLE-FINDERS

COMMUNICATING ONLINE

Great things do not just happen by impulse, but are a succession
of small things linked together. Vincent Van Gogh

RESEARCH

There are many reasons to be connected to the Internet—researching, purchasing, auctioning, blogging, forums, instant weather report, locating phone numbers and addresses and much more. My main usage for business is to do research. I don't know how I would be able to do what I do today if I constantly had to go to the library to try to locate information that is available at my fingertips online. It is truly amazing how much information is online and easily accessible. So many small companies are able to show what they do to so many people. This has truly created a revolution.

As an artist, you can search for information on grants, classes, studio space, an inexpensive place to stay while you visit NY (Craig's list), ideas, techniques, galleries, consultants, what other artists are doing to succeed; chat, tour a museum, locate an organization, check out a competition, do a research paper, join an art organization, buy supplies, send an e-mail card, and much more! Before the Internet, this would've taken so long, we simply wouldn't do it.

WHEN YOU FIRST START USING THE WEB

Set aside several hours—half a day or four hours would be good. At the end of this time you will be a semi-expert! Hopefully you will have searched other artists' sites, galleries of interest, consultants, etc.

CONDUCTING A SEARCH

You can find information on just about any topic you can think of on the Internet via a search engine: Google, Yahoo, Go2, Hotbot, Lycos, Netscape.

The way to find the web site that contains the particular information you need is by "asking" a "search engine" to locate "XXX info."

Search engines wander (creating a spiderweb of connections) through the Internet, constantly looking at new sites and revised pages. They record this information so that when we go online and ask for info, their database downloads current links to the information you are searching for.

To arrive at a search engine, either click on "Search" in the navigator bar of your browser or type in one of the search engines' names in the "Go to" line, noted above.

After the search engine locates some leads, click on the ones that you think might answer your questions; often it is the first one.

If there is a particular site you think you might want to return to, bookmark it; at the top of your screen there should be a scroll bar that says "Bookmark." Pull it down by clicking on it and go to "Add a Bookmark." Next time you want to find that site and can't remember the exact URL, pull down the bookmark scroll bar, go to "Show Bookmarks" and you will find it. Click on it and you can return to the site.

Art search engines and art directories make money through advertisers placing banners within their site. Some are art-specific:
art-search
art-search.us
wwar

CACHE

Whenever you go to a page, your computer downloads that page and puts it in a folder. This document is called a cache—a hidden treasure. Computers are generally set up to delete caches after a certain period of time. If you go to that same page a week later, most likely your computer will pull up the cached page from your computer, saving you time. If that page has been updated, you will not get the updated version. In order to get the most current page, you will need to hit Command R or Refresh for Reload (or find it in your scroll bars) to make sure you are getting the current page.

VIEWS

In most Internet programs these days, you can have several windows—search results—open at one time and flip back and forth. This is a huge timesaver: I can have my tennis schedule, banking, Google search and search results all viewable at the same time.

EXAMPLE OF SEARCH

I want information on ice-carving competitions. I can type in my search: ice carving, ice carving competitions, art of ice, art of ice carving, etc.

For my first attempt, I type (in quotes) "ice carving competitions" in the search engine. I receive 97 results from this search. I can decide from the short synopsis under each entry displayed which sites I want to browse.

When I do a second search for "ice carving competition" (non-plural), I get 5,684 results!

I decide to try "art of ice" and get 17 results.

TIPS

→ When you type in a phrase for a search, put it in quotes—for example, "art marketing." You will receive a more specific response from your inquiry than if you did not use quotes.

→ Always do your searches in lowercase letters. When I did a search of "ART OF ICE" in all caps, I got zero results. With lower case I got 17!

→ Be specific in your choice of words. For a more specific search, add a "+" before the most important word in your search—"+art of ice." The result will be more targeted.

→ Did your search bring up a lot of extraneous sites? To eliminate those, put a "-" sign before the word you don't want in your search, i.e., "+art -craft of ice." This will bring up pages that do not contain the word "craft."

When you see a company's e-mail address such as info@artmarketing.com, it means that www.artmarketing.com is their URL.

Spending at least one hour per week researching on the web will help increase your sales. Create an e-mail list for broadcasting to consultants, licensing agents, galleries, publishers, collectors and others.

Getting disconnected suddenly from the Internet is a common and frustrating problem. If it persists over a period of time, complain to your ISP.

→ If you want the word "art" to include variations such as "artist," "arts," "artwork," put an asterisk after the word art: "art* -craft of ice."

→ To quickly return to a web page you visited a few minutes ago: Click the "back button" on your navigator bar. You will see a list of the last few pages you have browsed through. Click the one to which you want to return.

WHAT YOU CAN RESEARCH

You can research all sorts of information related to your personal or business needs. For example, you can plan a vacation, look up medical information, research school courses, check out what is going on in your hometown, follow the news, and more. The list is endless.

▸ You can research other artists' sites too—there are thousands. See how they have set up their site and what you like and dislike about it. See what other artists are doing creatively.

▸ Shop for almost anything you need (or want and don't need).

▸ Find lists of art competitions at www.artdeadline.com or www.artshow.com.

▸ Research art publications, art marketing sites, web marketing sites, web design sites—the list goes on and on!

▸ See Chapter 8 for a huge list of links of resources for artists.

WWW.ARTMARKETING.COM/LINKS

Go the URL above and you can link to many sites in the following categories:

Art search engines	Auctions	Books, art-related
Consultants/reps	Copyright info	Framing
Galleries	Grants	Insurance
Jobs	Legal info	Libraries, art
Licensing agents	Lighting	Magazines, newsletters
Museums	Online galleries	Organizations, art
Printers	Private art studios	Publishers
Residencies	Resources	Shipping
Slide services	Software	Supplies and catalogs
Taxes	Theft and fraud	Travel

Not only can you find information (and lots of it) on any topic, but you can also locate people. You've probably heard of long-lost relatives being located through the Internet. If your lost relative or friend has an e-mail address, mostly likely you will be able to locate him or her.

Google has implemented a new feature that allows a user to type someone's telephone number into the search bar, hit enter, and get a name, address and map to the person's house! Search with forward slash and hyphen, i.e., 530/XXX-XXXX, and hit "enter." If the number is a business listing, you will find listed all the web sites that have your telephone number listed. If a number is not publicly listed, the address will not appear. If you want to block Google from divulging your private information, do a search for your number, then click on the telephone icon next to your phone number. You will see a link where you are allowed to remove your number, under the title "Phone Book" at the bottom of the section.

FINDING PEOPLE

Addresses, telephone numbers and zip codes can sometimes be found through a directory on the web, for free! Since 411 service on the phone can cost $1-$1.95 these days, it pays to do a Google search first. If it's a company you are looking for and you know its exact name and city or state, chances are it will pop up to the top of the list and might even have its phone number or address within the data there so you don't even have to click onto its URL.

Harder-to-find people can be searched for through www.bigbook.com, www. superpages.gte.net, www.guide.netscape.com/guide, or www.whowhere.com.

PEOPLE-FINDERS

COMMUNICATING ONLINE

CHAT ROOM

Besides being the world's largest library, the Internet is also the world's biggest entertainment lounge. You can find "rooms" in which to exchange ideas about art, marketing, or almost any other topic you desire. These rooms that hold conversations happening in "real time" are called chat rooms. Chat rooms can be a way of introducing people to your web site.

▸ Lead a chat on a site that needs an artist's advice: interior designers, corporations, printers, art councils, etc. These types of peripheral contacts often lead, over time, to purchasers of your art.

▸ Maybe you can locate a group of collectors from your local museum web site, or maybe you can start or sponsor a chat room with your local museum.

FORUM

A forum is similar to a chat room but usually doesn't happen in "real" time. You can post a message or question, and it might get answered later when someone is online and reads it.

NEWSGROUP

A newsgroup is a discussion group about a single topic. Find topics related to your artwork or interests, then contribute something to the conversations that take place. When you send your e-mail with its automatic signature, people will recognize that you are an artist and can link to your web site with a click.

EGROUP

A group of participants with a similar interest carry on questions and answers over long periods of time. For instance, when my sister and I were considering going to Peru, she sent a general question to her travel egroup and got great responses from very experienced travelers.

BLOGS

A blog (short for weblog) is a personal online journal that is frequently updated and intended for general public use. Blogs generally represent the personality of the author or reflect the purpose of the web site that hosts the blog. The author of a blog is often referred to as a blogger. Try www.blog.absolutearts.com, or www.dir. blogflux.com/cat/art.html.com. See Chapter 6 for details on how to create and use a blog to your advantage.

BLURB.COM

Where will the adventure lead? If you surf the Net, you will continue to find innovative ways to advance your business. Here's one of the newest that we've found: www.blurb.com lets you create a four-color book of your own artwork, art collection, travels, family, or whatever. For $29.95 you can have a 40-page, four-color, 8x10" hardbound book with dust jacket on high-quality paper. Make that soft cover and it's only $19.95 for 40 pages. Up that to 160 pages hardbound and it goes up only by $10, to $39.95. If you order 25 copies or more, you'll receive a small discount. The best thing, however, is that you can't tell the difference from a mass-produced book.

Online interface

For anyone who has a bit more than basic knowledge of the computer, it will be an easy process online to become your own book publisher. If you already have digital images on your computer, that makes it even more simple. Essentially you will drop or drag your images into the online template, a template provided by www.blurb.com that you have personally chosen.

- You will select font type.
- You will type in words.
- You will receive the hardbound (or softbound) book in approximately 10 working days!
- For future orders, you will be able customize your book for individual customers by going online and adjusting items.

Sales

Blurb.com hopes to have online sales possibilities in the future, giving authors royalty payments. Some people are already putting ISBN numbers on the backs of the books (often required when selling through a bookstore) and offering them through online stores such as www.amazon.com.

Check it out!

ACTION PLAN

❑ Conduct a search of galleries, corporate art consultants, interior designers, art competitions, grants, licensors and more.

❑ Reserve a hotel or make a reservation on an airline's web site.

❑ Find out about art marketing classes on the Internet.

❑ View other artists' sites and send e-mail comments.

❑ Search for an old friend or long-lost relative online.

❑ Chat at an artists' forum or chat room.

RECOMMENDED READING

Clicking Through by Jonathan Ezor

Chapter 4
Exhibiting Online

Online exposure for your artwork

Cyber galleries

Online art servers

Brick-and-mortar galleries

Net reps

Creating your own web site

MySpace.com

YouTube.com

Don't oppose forces, use them.
Richard B Fuller

ONLINE EXPOSURE FOR YOUR ARTWORK

Having online exposure—an online portfolio—is an absolute must if you are marketing and selling your own artwork. Many artists no longer produce slides; they just have digital versions of their original work, which they post on their web site. E-mail has also overtaken phone conversations. So get with it and make sure you are set up to conquer the current world! Art world professionals will think you are behind the times if you don't have some type of Internet exposure. Artists have several means of exposure online:

▸ Join a cyber gallery, sometimes called a web portfolio.

▸ Online art servers

▸ Brick-and-mortar gallery

▸ Net reps

▸ Create your own web site.

▸ MySpace

▸ YouTube

You will find online galleries that specialize in selling a particular genre of art—portraits, landscapes, animals, equine, abstract, etc. Use your favorite search engine to locate them:
- californiaart
- chinese-art
- ecologicalart.net
- marineart
- newyorkartists.net
- collageartist

For artists not familiar with the Internet, the simplest way to display artwork online is to be part of a cyber gallery.

▸ With a cyber gallery, you pay an annual subscription fee.

▸ Usually, the pages within a cyber gallery are "pre-formatted" (all the same layout), allowing a low-cost service.

▸ Cyber galleries charge $100-300 per year to show 4-10 images and a bio.

FINDING A CYBER GALLERY

Do a search using cyber gallery, online gallery, online galleries, on-line galleries, on-line gallery, «your specialty market« gallery, folk art gallery, pastel artists, etc. Look for the cyber galleries that showed up in the advertising bars on the side and at the very top of the search pages. Those are the cyber galleries that are paying to be there, giving you something for your buck if you choose to exhibit on them. Keep bookmarks on all the galleries you like or might want to be in.

CHOOSING A CYBER GALLERY

When you list with a cyber gallery, there are a few advantages:

▸ sharing online traffic

▸ no computer work; they do it for you

But remember, if the gallery has 200 or 2000 artists listed, you will face competition in its index. Online galleries do not promote each artist's work individually but invite clients to the gallery index, which lists all participating artists.

Ask them how they invite potential purchasers, gallery owners or consultants to their site. You not only want to see hits or visitors, you want art-oriented visitors— people who buy art! This is a much more difficult visitor to find.

TIPS

→ View the cyber gallery to see what it looks like.

→ Test out the cyber gallery; how does it function? Browse around a bit. Does it make it easy to find artists? Is it user-friendly?

→ Do a search at Google to see if one of their artists' names comes up at the top of the search.

→ Where does the online gallery advertise to bring in clients to view their artists' pages? Ask them.

CYBER GALLERIES

artbyus
artmarketing.com/gallery
boundlessgallery

The problem with most cyber galleries is that they do no advertising to bring clients to the site. If you have your own URL, you will be in the same situation—needing to attract clients to your site. This is discussed in Chapter 6.

→ Who is actually visiting the site: buyers of art, collectors, the art trade, art world professionals, other artists, the general public? Ask them. Make your own deductions.

→ How many hits per month does it receive? How many visitors?

→ Is it too cluttered with advertising?

DRAWBACKS OF CYBER GALLERIES

▸ With many cyber galleries, each time you want to update your pages, you have to e-mail a jpg and pay a fee.

▸ With 100 or more artists listed in the gallery, there is some competition. (That also means, however, that those 100 artists are sending their clients to the online gallery, which could ultimately lead them to seeing your artwork.)

▸ In many cases you will not be able to send your customers directly to your artwork; they will need to maneuver through the main gallery pages. Try to find a gallery where a patron can go directly to your artwork, not through the main pages of the gallery site.

NOT READY TO SPEND HUNDREDS OF DOLLARS TO HAVE A WEB SITE BUILT?

Take advantage of ArtNetwork's low-cost, high-exposure home pages. Our two-year plan is economical and allows you to have a professional "spot" on the web to call home.

Our 20 years' experience within the art world has made our site popular among thousands of art professionals. We contact these professionals annually via direct mail—they know us and the quality of artists we work with.

A home page with ArtNetwork will include five reproductions of your artwork (you can get a double page of 10 pieces if you like). Each artwork clicks onto an enlarged rendition, approximately three times the size. Two hundred words of copy (whatever you want to say) are also allowed on your main page.

Artmarketing.com receives between 400,000-500,000 hits per month—an average of 1500 users a day (and rising each quarter). The art gallery is the second-most visited area on our site.

▸ We pay for clicks on Google for a variety of art genres: abstract, equine, nature, environmental, whimsical and many more.

▸ We publicize our site to art publishers, gallery owners, museum curators, consultants, architects, interior designers and more! Your home page on our site will be seen by important members of the art world.

To showcase your work online, go to www.artmarketing.com/Ads

Online art servers are interactive web sites where you can upload your artwork directly from your computer to the Internet. Online art servers are user-friendly, charge a monthly fee, and enable you to change your own pages at your whim. In a sense, you become your own web master.

ARTROOF.COM

Here you can create a professional art site in a matter of minutes for $10-50 per month. Take a look at some of their sample galleries and then try their free trial. To get an idea of how it works, click their "Try Free" button and follow the directions. Any information you enter can be changed later.

MINDSISLAND.COM

For $6.95 per month you can post up to six images, post a resume, access job postings, have a blog with unlimited posts.

FOLIOLINK.COM

This service gives artists the tools they need to create and maintain one-of-a-kind art web sites. PC or Mac compatible. FolioLink is inexpensive—much less than hiring a web designer to initiate and update your site, partly because you do it yourself. (See Chapter 6.)

▸ The layout of the pre-formatted pages is easy to view and browse.

▸ The 50-page account is plenty for any artist who is starting out on the web. $20 per month.

▸ You can get a URL and e-mail address.

▸ You can send electronic postcards of your work, have video, audio, animation and much more.

ARTSPAN.COM

For $11.95-16.95, an easy template will enable you to upload pieces as you complete them.

ISPs

Many Internet service providers, such as AOL, Compuserve and Prodigy, offer web pages for you to upload to the Internet at no extra cost. On AOL you can upload up to 10mg (over 50 pages). You don't need to know any computer language or coding scripts. It's all available in user-friendly format. Access your service providers' Members Services section for specific details.

ONLINE ART SERVERS

Somewhat like a slide registry, you upload and manage your artwork yourself online.
art-exchange
wwar

WEB HOSTING SERVICES

For a small fee per month, these sites will enable you to upload pictures: Angelfire, Bizland, Doteasy, Dreamwater, Freeservers, Geocities, Hypermart, Netcolony.

ONE-CLICK WEB SITES

If you have a Mac, you can create your own web site, complete with video, podcasts and photo galleries in the time it takes a PC to churn out a blog entry.

TIP

If you want to create a video blog, use a MacBook Pro or iMac's built-in iSight camera—a video camera nestled at the top of your screen. Just launch iMovie and it records your latest rantings. Once recorded, you export it to iWeb. You will need to open a .Mac account at www.apple.com.

If you are part of a brick-and-mortar (traditional) gallery, your work most likely will be shown on that gallery's web site. Unless you have an exclusive contract, you might want to list your work elsewhere, as well.

Many art organizations have online galleries. Join, and for a small fee, you have the privilege of showing your work online. Some such organizations are www.watercolor-online.com, www.pastelartist.com, www.sama.com.

BRICK-AND-MORTAR GALLERIES

Most likely, a gallery contract will not prevent you from having a web site, but it might preclude you from selling work from your site. Check your contract.

NET REPS

Somewhat like a brick-and-mortar gallery, some sites require your work to be juried in before they will represent you. Sites that jury in an artist are what we have dubbed "net reps." Often, they will have the artist sign an exclusive contract for Internet sales. Acting like live reps, they advertise in consumer and trade publications to sell the artwork they have listed online. Generally, they take a percentage of sales, much like a traditional gallery. Most of these reps require that you do not show anywhere else on the Internet. Consider this option carefully if that is one of their requirements. Some sites are:

- nextmonet
- fine-art

Leaseart.com

Did you know that a corporation can write off up to 30% of the lease price on a piece of art by leasing-to-own? Leaseart.com's sales pitch is based on that idea. Check this site out. It might open a new venue for your art.

Prints

If you have prints to sell, there are also net reps that sell prints:

- allaboutart
- barewalls
- easyart
- posterbrowser
- theartsource

Creating your own web site from scratch is no easy task. I suggest exploring the venues on the preceding pages and starting by exposing your work through one of the cyber galleries or art servers. This will give you a bit more experience before you leap into the site-management world. If you decide to develop your own web site, it will take several months to do it right, even if you have a web designer helping you. Chapter 5 goes into more detail of what you will need to do if you decide to go this route. Here is one step you might want to take even if you decide to postpone this task for awhile.

APPLYING FOR A URL

You can apply for and receive a URL without publishing a web page for years. As long as you pay your annual subscription fee—$20-35—you can retain that URL domain name forever.

IDEAL URLS

▸ Think carefully about the name you ultimately choose. When ArtNetwork wanted to acquire artnetwork.com, it was already taken. We could have purchased artnetwork1.com, artwork.com, networkart.com, theartnetwork.com. After several days of considering a variety of URLs, we thought artmarketing seemed to be the most appropriate. We are still happy with this choice. In fact, we have considered changing our company name to Artmarketing.com! So, take your time and be intentional.

▸ When choosing a URL, follow the same tips as when selecting an e-mail address (Chapter 2, pages 20-21).

▸ Whatever letters or numbers you choose, your URL should be no longer than 20 characters. The shorter the better.

▸ An extra dash or unusual character will make your URL more difficult to verbalize, as well as more difficult to type correctly.

Try to make your URL as short as possible, but more importantly, make it:

▸ easy to remember

▸ easy to pronounce (which you'll do a lot of on the phone), and

▸ easy to spell.

WHERE TO SIGN UP

There are several places you can register for a URL, with a variety of fees ranging from $20-35 per year. Don't let anyone register a URL for you, because, ultimately, they will own it! Do it yourself online at www.register.com.

CREATING YOUR OWN WEB SITE

The ultimate purpose of your site is exposure..

If you decide to have a web designer create a web site for you, be prepared to pay between $700-1500 for the initial design. An artist recently told us he paid $3000 for 6 pages! Plan $50-100 per month for updates.

MYSPACE.COM

With all the controversy as of late, I'm sure you've heard of MySpace. Essentially, www.myspace is an online community that enables you to meet people and tell them who you are. You can create a private community on MySpace, and can share photos, journals and blogs of interest with others.

It is similar to a blog (see pages 72-73). As of now, however, the search engines don't index the information, and thus you won't turn up when someone does a search for a particular topic you might be ranting about. For business purposes, then, you need to create a blog. Use MySpace as one way to let people know about you—the artist. Post pix of your artwork. Correspond with other artists and view their work.

FRACTUREDATLAS.ORG

This is an organization that assists artists in a variety of ways (insurance, business, marketing). They are intending to create a network similar to MySpace, but solely for artists.

YouTube ranks in the top 13 web sites (by the time you read this, maybe even higher). It's hard to fathom, but over 100 million videos are viewed daily on YouTube. I didn't even know I became part of that count when a friend e-mailed me a link to some of my now-favored videos (french ventriloquist mime, beatles juggler (and jugglers in general), the infamous "bus uncle," dancing man from Midwest Judson Laipply. An upstart site in the Spring of 2005, two years later www.youtube.com has over 50 employees. Each day more than 50,000 new videos—dinky home videos, well-taken documentaries, advertising—are uploaded by individuals like you and me. Clip length is limited to ten minutes. The Director's program, however, will allow full-length videos. Put in a search word and then start viewing. There are lots of pet videos, amateur musicians, vacation fun, lip-synching, and more.

YouTube is totally free, at least for the time being.

So, artists, you too can upload videos of your artwork, of you creating your artwork, talking about your artwork, showing a project dear to your heart, etc.

- As usual, title your video appropriately but with interest and it will get viewed.

- Note your web site address and name so you can easily be found.

- Put a link on your web site to your YouTube creation.

YOUTUBE.COM

Following the success of YouTube, Yahoo and Google are adding free video uploads to their sites.

ACTION PLAN

- ❑ Check out some cyber galleries.
- ❑ Investigate an online art service.
- ❑ Check out one-click web sites.
- ❑ Ask your brick-and-mortar gallery about exhibiting your work online.
- ❑ Fine a net rep online.
- ❑ Get a URL.
- ❑ Choose one or two modes to exhibit your work online.

Chapter 5

Six Steps to Designing Your Web Site

Research

Developing a site map

Visual direction

Creating the pages

Behind-the-page data

Publishing your site

It don't mean a thing if it ain't got that swing.
Duke Ellington and Irving Mills

RESEARCH

If you have a web master set up your site initially, try to learn the software program he is using so you can update the basics when you need to. This will save you considerable bucks, but mostly it will give you quick accessibility to updates and put power back in your hands.

Your aim as an artist showing artwork on the web, as with all your promotion, will be to use it as a portfolio to exhibit examples of your artwork. It is not the end-all, only part of a bigger plan.

It is important, whether you have the help of a web designer or not, that you know some basic things about what makes up a good artist's site. This chapter is not meant to be a design manual but simply a guide to the general concepts of creating an easy-to-maneuver and pleasant art site. At the end of this chapter, you will find references to several books on web design. We suggest you study those if you will be designing your own site.

Many simple web-design software programs exist: Dreamweaver, Front Page, Home Page and more. Professional designers use these programs, and you can too.

CHECK OUT OTHER SITES

Print out pages you like while you browse other artists' sites on the web. Also print out their source pages. To find a source page: Under the View pull-down-bar, go to View Source. You will find all the HTML that created the site as well as all the keywords used to help search engines find their site. Print out and highlight what you like. Learn from this research how your design needs to be and how it will distinguish your site from the crowd.

- ▸ What background colors attract you?
- ▸ What types of layouts do you like?
- ▸ What features do you like about the pages you visited?
- ▸ How do their links work?

You should have a good idea of the direction you want your web page to go visually before talking to a web designer. Your web designer can then take your ideas and create the actual pages.

UNFAVORABLE SITES

Also print out sites you don't like. Make a note of what you dislike. They don't have a particular flow? Too corny? Is your artwork more serious? Ultimately you will realize what you want to emphasize on your site.

TIPS

- ▸ Take a web design class. Make sure the class is being taught with a software program that is compatible with your computer.
- ▸ Read some web design books (see end of this chapter).
- ▸ Browse sites on the Internet that have resources for building sites (Chapter 8).
- ▸ Decide on a specific style, theme, background color, etc.

Sites to browse:
- silkspirit
- diegorivera
- douglass-truth
- renegriffith
- designwithnatureltd
- elizabethturnbull.com.au

The next step is to create a site map. A site map is an actual page that will be on your site. It is a simple outline without visuals of how to navigate your site. Each listing will be a link to the area to which it is referring. Links to this site map should be available from your site pages. As you learn to research online, you will find that a site map is sometimes the easiest way to maneuver around a site.

WHAT TO INCLUDE IN YOUR SITE MAP

Since your web site will become your online portfolio, you will want to have everything your in-hand portfolio has:

▸ Images of your artwork, noting medium, size, title and price range or price

▸ Bio

▸ Statement

▸ Exhibitions list

▸ Contact info

▸ Press release

▸ Links

▸ Some unusual page to capture collectors' interest

▸ Shopping cart

▸ Subscription form or guest book

▸ Feedback form

▸ Chat room, blog, bulletin board

GUEST BOOKS

Give visitors the chance to leave their comments, e-mail address and home address so that you can contact them. Search for "free guest book" to download one for your site. Be sure to have a link from every page to your guest book, so a visitor can easily sign it whereever they are on your site. Your ISP should be able to help you with adding a guest book to your site.

404 ERRORS

Most likely, the software program you are using will have a built-in "link-checker" to verify that all your links are working. Should one of your links not work, a "404" error page will appear to the visitor. You can customize your "404 error message" to say whatever you want. It can also redirect the user back to your home page.

DEVELOPING A SITE MAP

Keep in mind that you have only eight seconds to hold the attention of your viewer. If your page doesn't pop up within eight seconds, you might lose your visitor.

SAMPLE SITE MAP

Home
 Contact
 E-mail, telephone, etc.
 Guest book for capturing customers' e-mails for recontact
 Blog
Artwork
 2008
 2007
 Abstracts
 Landscapes
 Commissions
 Prints
 Article "What is a giclée?"
 List of prints available
Calendar
 Ongoing shows
 Upcoming shows
 Art shows of interest to the general public
 Cool art events around the U.S.
Reviews of your artwork
 Magazine reviews
 Testimonials
Viewpoint of artist
 Video reviews
 Book reviews
 Newsletter
History
 Bio
 Statement
 Life story
Links
 My favorite links
 Cool sites
 Helpful links
 Fun links
Purchasing
 Shipping and handling policies
 Terms of purchase; guarantee
 Shopping cart

When you have an outline—your site map—you can start thinking about the details of how each piece of your map will look.

GENERAL DESIGN TIPS

→ Keep your theme, logo and layout consistent.

→ Use no more than two or three font families.

→ Show products and services you will offer: originals, prints, other items.

→ Identify the main purpose of your site.

→ Display your artwork no larger than 5x5" or so.

→ Design a template, i.e., navigation bars, columns, tables, headers, logo.

→ Have user-friendly navigation—for instance, a phone number and e-mail link on each page.

→ Make it possible for your visitor to go from section to section easily, without backtracking.

→ Have all your main site paths linkable to each page: artwork, prints, calendar, review of artwork, links, viewpoint of artist, history, purchasing, contact.

→ What will a client remember when he comes to your site to browse? Show your creative attitude through the design.

→ Speed is an important design factor. Each page should download within 5-10 seconds. Test and check each page.

→ List your prices! Label each work of art with the retail price. Why hide a good thing? People may think your artwork is too expensive if you don't inform them of the price.

→ It's fine (in our view it's as good) to exhibit artwork online that has sold (noting, of course, that it has sold). This entices viewers.

→ Exchanging links increases your search engine presence. Have a links page. Be innovative when exchanging links. Are you an environmental artist? Then find environment-related sites and ask them if they would like to exchange links. We recommend staying away from exchanging banners—just use word links. Too many banners on a page take too long to download and often create a sloppy impression.

→ Keep your site simple. Too many bells and whistles are distracting.

→ No blinking graphics. Visitors did not come to your site to see how good a web designer you are; they came to see your artwork.

VISUAL DIRECTION

Personalize your site. Try not to follow the pattern of typical, banner-inflated sites.

SITE INNOVATION

- One artist (www.douglass-truth.com) created a great web site with "Dorothy's Page." Dorothy is a fictional twin sister who confiscates this artist's work and sells it behind his back at a lower price. This idea got me to bookmark his site and go back there periodically to check on possible sale items.
- www.traceyporter.com has a link for "Dreamers and Entrepreneurs." This link caught my attention. I clicked on it right away.

→ No audio; your site is an art site, not a musical site.

→ No advertisers; visitors have come to see your artwork. Don't distraction them.

→ Have your logo and/or name on every page.

→ Font should be easy to read, not too small. Make sure the color of the type contrasts well with the background color.

→ Dark backgrounds are not good for reading; for visuals they're okay.

→ If you will be out of the office for a period of time, post a message on your home page indicating so. You don't want visitors to think that you don't answer e-mail.

→ Display testimonials from people who have worked with you—consultants, galleries, buyers, etc.

→ Be sure to list sales you have made to well-known collectors on your bio page.

→ Post any new items or events on your home page, with a link to a more detailed page. Otherwise, clients might not notice or find them.

→ Include a casual picture of yourself, perhaps working at your easel. It helps people remember you.

→ Post your life story, along with a well-composed bio and statement.

→ If you are going to develop a newsletter, make past issues available to visitors in archives. Potential clients will like the fact that you have been developing as an artist over time.

→ Splash pages are not necessary—just get to the point!

→ Pick a theme, then design your page headers accordingly, or use your logo as a header.

→ Ask yourself what viewers want to see when they arrive at your site. Provide that for them.

→ Clarify your personal goal regarding the site. What do you want your visitors to know? What are your best assets?

→ Remind your visitors to bookmark your home page.

→ Solicit feedback from visitors through a survey, a question about how they select artwork to buy, etc. This can build traffic and provide e-mail addresses.

BUYING ONLINE

Buying artwork online will become more and more accepted as time goes by. Presently, most people are hesitant to purchase an original piece of artwork online. Some ideas you can incorporate into your web site to help them overcome this hesitancy include:

▸ 30-day approval

▸ money-back guarantee

▸ trade-ins

▸ payment installment plans

▸ framing service

▸ good customer service

▸ house visit (if possible)

THE BIGGEST MISTAKES IN ARTISTS' WEB SITE DESIGN

→ Low-quality photos
→ Takes too long to open
→ Confusing navigation
→ Links that don't work
→ No place to capture your visitors' e-mail for future marketing
→ Your data—name, e-mail, telephone, URL—is not on every page.
→ Too flashy and time-consuming
→ Animation, blinking, music with no choice for alternative
→ No prices listed—the consumer will think your work is out of their price range
→ Too many banners and unnecessary ads
→ Pages don't print out easily on an 8.5x11" sheet
→ Visuals are not consistent throughout; logo should be on each page

CREATING THE PAGES

IMAGES FOR THE WEB

The most important part of displaying your artwork online is starting with a well-reproduced image. Digital cameras can be used for this purpose. Be sure to have lots of light when you take your photo—preferably natural light. Once you have a digital picture of your artwork, you will need to adapt it for the web by using a photo imaging program.

Photo imaging programs are fun to use but take a while to learn. Most graphic designers know how to use photo imaging software. You can create jpgs for online use with these programs.

All scanners (flatbed or slide) come with basic photo imaging programs that can size, rotate, colorize and twist images. This simple software is, most likely, all you will need to set up your site, providing your digital image is well taken. (See Chapter 1 for more info.)

TIPS

→ Since small images are faster to download, give your viewers the option to choose which piece they want to see enlarged by listing a small thumbnail first. Large pieces should be no larger than 500 pixels in any direction. That way, the entire piece will be viewable at once on most monitors.

→ By definition, a jpg's resolution is 72dpi (dots per inch). Many artists do not understand this concept and have sent us jpgs that are 300dpi—a resolution good enough for printing and too high-quality for exposure on the Internet. For example, should someone download that image, they could actually use it to reproduce posters. If they downloaded a true jpg (72dpi), the print quality would barely be good enough for even a newsletter.

→ www.ulead.com can help you optimize your images—that is, make them the most compact they can be. If you have many large images, or 30-plus small ones, on one page, you will need to do this.

→ If you must make a choice, have your images be lighter rather than darker than the original.

→ Break down web pages into sections so that they are not too long, with no more than 20 thumbnails on one page. Divide styles among different pages—perhaps two genres, such as landscape and abstract.

→ Jpgs must be created in RGB format.

RESOURCES FOR PHOTO IMAGING SOFTWARE

▸ Adobe Photoshop is the most widely known imaging software program. If you plan to use this sophisticated program, you'll probably need to take a class to understand its full benefits. Adobe also has a "consumer-grade" program that runs about $99. Find it at www.adobe.com.

▸ PaintShop is a less expensive program and quite sufficient for creating images for the web. Find it at www.corel.com.

▸ You might find some photo software for free at www.shareware.com.

COPYRIGHTED IMAGES

All artwork is automatically copyrighted by the creator as it is being created. As discussed in *Art Marketing 101*, your best protection is to register your copyright in the Copyright Office in DC.

Although doing so breaks copyright laws and is punishable by law, an image on the Internet can be copied quite easily from your site to another. Most people are honest and do this only if they've asked for permission from the owner of the copyright. Unfortunately, there is not much you can do if someone steals an image of your artwork and posts it on their page without permission.

▸ To protect yourself as much as possible, use 72dpi jpgs: Their printing quality is not high enough for commercial purposes.

▸ If you find your artwork on another site, approach the site owner about it. He might not be knowledgeable about your legal rights as creator and copyright owner.

▸ If you feel more comfortable doing so, you can actually incorporate your name on the images before you put them online.

▸ Digitally watermarking your jpgs is another possibility for protecting your work online, but it can be costly for individual artists. Stock photo companies embed watermarks, enabling them to find any misuse on the web.

Remember: This is your site, not a site for a web designer to show off his super-techno abilities.

BEFORE DESIGNING YOUR OWN WEB SITE

Think thoroughly about the entire process before you decide to design your own web site.

Have you done design work before?

Have you used the computer previously to do design?

Are you skilled on the computer?

Are you willing to take several months to learn the program with the help of a local class?

Are you willing to give up art-creation time for computer learning?

Do you have a fairly new computer to make the process easier?

WEB DESIGNERS

Web designers generally charge $35-100 per hour. If they are in high demand and busy, be prepared to pay $75-plus an hour! Just the fact that they charge a lot doesn't mean they are fast. You should be able to get a comprehensive quote, especially if you have read this chapter and have outlined a preliminary version of your site. The minimum price I have seen for a home page design for an artist is about $375-750. That includes only one to five pages of design. Most sites cost a minimum $1500 and have about 10-15 pages. Depending on how many updates you plan to do during the year, you should estimate a minimum of $300-500 per year for updates. In addition to your web design fee, you will have an annual URL registration fee (about $10-35) and monthly ISP fees (about $10-25).

The best way to choose a web designer is to surf to a web site you like and see who designed it—usually their e-mail and name are at the bottom of the first page. (The designer usually owns the copyright to the pages she creates, even if they contain your company's information.) We list here a few designers who have experience working with artists' sites.

It is best to find a designer who can do both the behind-the-page (coding for search engines) and exterior design (the visual look).

CONTACTS

Beautiful Artist Web Sites
www.beautifulartistwebsites.com

Chris Maher
www.chrismaher.com

Darryl Rubarth

775.884.0699 www.zartist.com

Kelly Ludwig

816.268.0939 www.detourart.com kelly@detourart.com

Kelly runs a wonderful site on what I call visionary art that you can explore around the country.

Kurt Irmiter

828.658.2779 www.festivalnet.com kurt@festivalnet.com

He is ArtNetwork's ISP host and helped us design a few of our CGI pages. He is customer service-oriented, which makes a big difference in efficiency.

Growth Communications

Steve White, 7 Riverview Dr, Norwalk, CT 203.847.6283

www.growthcommunications.com

WEB DESIGNER CONTRACTS

▸ Agree on copyright ownership.

▸ Agree on cost of initial development and what it includes.

▸ Agree on cost for updates after initial development.

▸ Ask for the right to keep a copy of your site's backup on your computer so you can update and work on it yourself.

DID YOU KNOW?

When you hire a web designer to build your site, it becomes the copyrightable artwork of the designer—just as when you create a commission for someone, it is your copyrighted image, not the buyer's. If you want to change or update the site yourself in the future, or hire a different person to update it, you cannot!

The only way to avoid this inconvenience is to have a written agreement with the web designer indicating that you own all the rights to her creation and that you can change it as needed. If the web designer doesn't agree to that, find a different one!

BEHIND-THE-PAGE DATA

Once you have the visual portion of your site designed, you will want to dedicate time to designing the "behind-the-page" data.

Hidden from view within every page on the Internet is a group of "meta tags" made up of keywords, description and title—hidden to the naked eye but visible to search engines. Search engines use these meta tags to categorize your site.

KEYWORDS

When thinking of keywords to use to promote your work, try to think the way someone searching for your type of art would think. A collector might be interested in vibrant colors, abstract expressionism, living artist, price range, etc. These words are what you want to list in your keyword section.

Find out what other artists are using for their keywords. When on their sites, click View on the navigator bar, then go to Page Source. You will be able to see keywords they use on their pages.

TIPS

→ Because the word "painting" is so generic (as well as gallery, artwork, artist), a search done using just the word "painting" will pull up millions of sites. Use words that are specific—for example, spiritual art, shamanic art, three-dimensional painting, earth works, sublime art, sculptural ceramics, etc.

→ Don't repeat words in the keyword section. You can have variations on each word, such as art, artist, artists, arts, art world, artwork, etc., but do not put artist, artist, artist.

→ When using a phrase like "commissioned portraits," the keywords could read: commission, commissioned portrait, portrait.

→ Separate keywords by commas. No spaces are necessary.

→ Have your first and last name together as well as separate: ivo david, ivo, david.

→ Search engines search by text content, not image content.

→ Put all keywords in lowercase.

A site where, for free, you can create meta tags and keyword groupings that will best promote your site is www.wordtracker.com.

WHAT THE HIDDEN CODE LOOKS LIKE ON A SITE

HTML

HEAD

META NAME="keywords" CONTENT=" steppen david, steppen, david, oil painting, oils, painting, acrylic, collage, new age, two-dimensional, oil on canvas, artwork, fusionism"

META NAME="description" CONTENT="Gallery carrying two-dimensional artwork of steppen david, including oil, acrylic and collage"

TITLE=Steppen David /title

/HEAD

KEYWORD SECTION

DESCRIPTION SECTION

PAGE TITLE SECTION

DESCRIPTIONS

In the description section of your meta tags, you will be writing, in sentence format, a summary of your site. Pull out some words from your keyword section and use those in your description. You can have several sentences within the description. This description is what comes up when someone does a search.

TITLES

Be very specific with the title on each of your pages. The title plays an important role in the process that determines where your page shows up on a search engine. The title is the first thing the spider of a search engine looks at. A title should be helpful to visitors, but also useful to search engines. Use no more than five words; the shorter and more concise, the better the search engines respond.

SECURED SITE

A secured site is necessary when selling items (books, prints, mugs, magnets, etc.) at low prices ($1-99). For a fine artist selling original artwork, a secured site is not necessary. You can use PayPal. Potential clients of original artwork (ranging from $250 and up) will normally want to talk to the artist before purchasing. In fact, it's better, if you're selling only originals, to have the potential client call you. That way you will have more personal contact and will be able to help them better—perhaps even sell them more. There is no substitute for a one-to-one meeting or phone conversation with a purchaser.

Repeat important words in all three sections—keywords, description and title.

63

A client may want to pay with a credit card. If you are already set up to accept credit cards off-line, take her credit card number over the phone and process it. If you are not set up in this manner, perhaps you want to use one of the secured paying services to accommodate your client's needs. Alternatively, you can accept a standard check.

SECURED PAYMENT SERVICES

A company like PayPal can be used on your personal site to collect funds for payment by customers. For detailed information, see Chapter 7, pages 86 and 91.

SHOPPING CARTS

Shopping carts cost a fair amount to set up, but they are a real advantage if you have the appropriate items to sell (books, prints, mugs, magnets, switch plates, artwork under $100).

For an individual artist, a shopping cart is not needed unless you are selling prints, magnets, cups, cards, etc. If you think you need to have a shopping cart on your site:

▸ Go to www.shoppingcarts.com.

▸ Go to an "online site builder" such as www.monstercommerce.com, a shopping cart system to which you can subscribe, costing as little as $5 per month.

Once your site is designed, it will need to be uploaded/published/posted onto the Internet. You will need a File Transfer Protocol/FTP software program to upload your pages. Most of the more sophisticated site-design software programs have upload programs built into them. If you've hired a designer, he will do this for you.

ISP HOSTS

Similar to an ISP for e-mail, you will need an ISP to "host" your web site. Sometimes the same ISP can host your e-mail and your web site. Call your e-mail ISP to see what they offer. Costs vary according to how many pages you publish. ArtNetwork's ISP server charges $50 per month for about 1000 pages. As a small user, perhaps with 20-40 pages, you might pay $10 per month. AOL users, for instance, can get 10mg of storage (several hundred pages) for free.

ISP HOSTS SHOULD OFFER:

▸ Auto responders (see page 25)

▸ Design assistance at an hourly rate

▸ Customized forms such as feedback, guest books or order forms

▸ FTP access

▸ CGI bin or shopping cart software with secured site

▸ E-mail boxes for your various aliases

▸ Statistical reports that will tell you how many hits, visitors, etc., you've received at your site and for any given page.

SOME ISP HOSTS

easyspace	globalspacesolutions	gate
registernames	simpleurl	web

FESTIVALNET.COM

ArtNetwork's ISP host, www.festivalnet.com, provides space for small companies. Festivalnet.com has friendly service and advice. The owner, Kurt Irmiter, runs an arts and crafts-related web site as well. He can help you design and install pages, send press releases, install CGI code for shopping carts or order forms, promote your site to search engines, or set up a secured site. For artists, he provides the kind of personal service you need.

PUBLISHING YOUR SITE

FREE HOSTING

The old adage, "You get what you pay for," has never been more true than when it comes to free ISP hosting. There are free ISP hosts; however, there are many drawbacks. We recommend that if you are going to the trouble of having a web site, pay for the storage of it online. Don't use a free hosting service.

DRAWBACKS TO FREE HOSTING

▸ Many require putting their advertising banners on your site—a major pain to your customers. It looks tacky and takes longer to download the site as well.

▸ Customer service is poor, if not outright nil!

▸ Free hosts tend to go out of business overnight; then your site is down until you locate a new ISP.

▸ They've been known to become commercial; thus you end up paying for the space anyway.

FINAL CHECKING

After you've uploaded your site to the Internet, you will need to make sure it looks good, works well, and links and prints out correctly.

▸ Test your site on a "foreign" computer—your friend's, a local Internet cafe, the library, etc. It might appear differently on all those computers. Make sure you try it on both a Mac and a PC. You can also check how fast it downloads on each one.

▸ Check for spelling and grammar errors.

▸ Double-check all the links.

▸ Check for color scheme, layout and visual balance; but remember, not all computer screens are created equal.

▸ Have several people, both friends and business associates, review the site before you advertise it to the world. See what they say. Do they find it user-friendly?

▸ When all looks good and works well, you are ready to let everyone know you are up and running.

Tracking broken links online: Your software program will most likely have a built-in link-checker to see if your pages have broken links. If you do not have a checker within the software program, you could use: www.netmechanic.com, www.anybrowser.com or www.linkalarm.com.

TIPS

→ Test all pages by printing them out.

→ Don't use strange characters in your file names, such as #, ?, *, etc. They can create errors when uploading to some sites.

→ If you don't have the correct suffix (.html, .jpg) in a file name, it won't be recognized by the World Wide Web and will not link properly.

www.optiview.com helps fine-tune sites by checking the download time. It estimates how a shorter download time can be achieved by editing images for free.

ACTION PLAN

❏ Search other artists' sites for ideas. Print out the pages you like or dislike.

❏ List three things you want your visitor to do at your site.

❏ Design a site map.

❏ Identify the main purpose of your web site: What do you want to say about your artwork?

❏ Decide on an approach to your site: formal, casual, whimsical, etc.

❏ Draw a rough layout of your site's design on paper.

❏ Decide whether to build your site, hire a web designer or use an online gallery.

❏ Write keywords, title and description for your main page.

❏ Test your site.

RECOMMENDED READING

Creating Killer Web Sites by David Siegel

Creating Web Pages for Dummies by Bud E Smith

Design Your Own Home Page by Molly E Holzschlag

Designing Web Usability: The Practice of Simplicity by Jakob Nielsen

Digital Photography for Dummies by Julie Adiar King

Don't Make Me Think: A Common Sense Approach to Web Usability by Steve Krug and Roger Black

Electronic Highway Robbery by Mary E Carter

Home Page Usability: 50 Websites Deconstructed by Jakob Nielsen

How to Design and Build the Coolest Website in Cyberspace by Jerry Glenwright

User-Centered Web Design by John Cato

Web Pages That Suck by Vincent Flanders

Making a Splash on the Web

Promotional prep

Links

Blogs

Online marketing tactics

Securing return visitors

You must do the thing you think you cannot do.
Eleanor Roosevelt

PROMOTIONAL PREP

In this chapter, you'll be shown a variety of ways to get quality visitors to your site. You've spent lots of money and effort to get your artwork online. Don't blow your investment by ignoring promotion. Energy spent promoting your site is the only way you'll get potential clients to view it and thus visit your studio, call you and ultimately exchange money for art. Even if you are part of a cyber gallery, this information will help to get visitors, and hopefully buyers, to your site.

ATTRACTING BUYERS

As a fine artist you will not be thinking of promotion in the same way a large company does. You need to think of attracting individual, quality clients.

- Concentrate on certain key art professionals such as interior designers, corporate art consultants, architects, private collectors, publishers, licensors, etc.

- Why would they be searching for you? Did they see your work at a gallery or show? Did you give them your business card at an exhibition?

- In Chapter 3, you began doing research and now have a small gathering of art world professionals on your e-mail list.

Don't forget to put your URL on all your promotional materials. It becomes your address.

Create as many paths to your site as possible via links on other sites. Linking your site to a site that is associated in some way with your artwork is one of the best ways to drive potential customers to your pages.

To know what sites you might want to trade or exchange links with, think about what sites your potential clients might be browsing. If you do floral paintings, perhaps clients interested in nature-type paintings might browse to gardens, nurseries, flower arrangers and flower sites. Check out these sites by doing a search on Google. Then ask each site individually if you can exchange links.

- If you've written an article, perhaps this site would want to feature it. Many site editors are looking for content, so don't be shy if you have a good article to submit.

- Offer the use of one of your floral art images for them to use on their site.

- Link to art galleries, art organizations (especially your local arts council) and art publications. Join and support your local art organization. It is the most common place a person searches for a local artist to commission a mural or portrait.

AFFILIATE PROGRAMS AND BANNER ADS

Once your site is up, companies may approach you by e-mail to ask you to participate in their affiliate programs. This usually means placing their banner ad (logo) on your site. Don't clutter your site with this sponsorship unless it means:

- a great deal of publicity for you on their site

- direct cash and lots of it, and/or

- involvement in a cause dear to your heart.

RECIPROCAL LINKS

You will need to design a page that will list all your reciprocal links. Too many banners on a page take too much time to download and often look chaotic. Go for simplicity: List links by the name of the company and a short description, i.e., ArtNetwork - business books for artists.

LINKS

Links allow connections between sites.

Broadcasts, chat rooms, blogs and egroups (discussed in Chapter 3) are other tactics to promote your URL.

BLOGS

A blog is a communique from the gut, a daily diary, your own soapbox. Blogs are the hottest thing on the Internet.

STARTING A BLOG

It's simpler than you think! Go to www.google.com. Select More. Select Even More. Select Communicate, Show & Share. Select Blogger. At that point you are three steps away to official blogdom. Then all you need do is add content. As with most blog sites, you will be provided with custom templates, colors and fonts.

Not only do you get to post your personal thoughts, but if you want you can get responses to them. You can choose to delete those responses you don't like. You can make your blog private for those chosen few. You can have a group blog with a variety of authors. You can share photos. Rosie O'Donnell even has a blog you can read.

▸ First you will want to declare yourself an expert at something; you probably are an expert at something already! Use that expertise topic to initiate your blog. If it's not directly related to your art, figure out how it could be.

▸ Create a great title for your blog: ArtAddict or Diary of a 33-year-old artist, etc.

▸ Create a short description to go with your title: Daily encounters with your hidden self.

Once you open a blog, write consistently and often (at least two times a week). Blogs are well-loved by the spiders on the web (the ones that lead to search engines), so the more often you post, the more often you are put at the top of the search engines and the word spreads.

▸ First impressions do count, both in words and design elements. Information, especially when useful or entertaining, is key.

All these aspects—a blog, articles on the web, a nice web site—add to creating the credibility factor.

TIPS

→ www.mybloglog.com offers a free "widget" that enables you to build a free community around your blog.

→ www.hittail.com analyzes search terms leading to your blog traffic and will choose higher-ranking words for you to focus on.

→ Blogs usually enable response; questions and comments. Be sure to answer as many of those as you possibly can.

→ When you refer to something in your blog that has an online site, create a link to it.

Online sites where you can create a blog:
blogeasy
blogger
blogspot
google
lycos
squidoo
wordpress

→ Read the article at www.theartrepreneur.com/knowledge/artist_blog.asp

→ Be sure your e-mail signature has your blog URL(s) on it.

→ If you have a favorite blog, subscribe to www.bloglet.com. It's a free service that will send you an e-mail alert each time that blog publishes a new post.

MARKETING YOUR BLOG

Marketing a blog is similar to marketing a web site:

▸ Participate in forums (see page 36). Forums have lots and lots of pages with lots and lots of members.

▸ Participate in other blogs with appropriate topics.

▸ www.blogburst.com, for a small fee, will inform newspapers about your blog.

▸ Submit to blog directories, Google, etc.

▸ Let blog directories and search engines know that you have updated your blog by "pinging" them: www.ping-o-matic.com lets you ping (inform) many sites with one click.

▸ Join www.blogcarnival.com. Anyone who joins can view the index of blogs.

▸ Get interviewed and post it.

▸ Pass the word on about others in your subject of interest by interviewing them. It's a great way to meet those special people.

▸ Create something free (an ebook) and give it away as a PDF. Be sure to include a link (within the document) back to your site.

▸ Create free stuff for other sites to distribute (an ebook).

▸ Network with other bloggers or become a guest blogger at another site.

▸ www.helium.com is a site where you can read articles on many topics, as well as submit articles on your subject-of-knowledge. Being listed there will demonstrate that you are an authority on that topic. Through a link back on your profile, you can get traffic to your blog or web site.

▸ Article directories—ezines (magazines)—might list your article if you have the proper topic.

▸ Participate in Yahoo Answers. As a specialist on a topic, you can answer questions and inform people of your blog or web site.

Some art-related blogs to visit:
artnetwork-artmarketing.blogspot
www.renegriffith.blogspot
paintingaday.blogspot
artbizblog

Blog directories are similar to art search engines:
9rules
b5media
blogarama
blogcatalog
blogdex
blogdigger
blogflux
bloghub
blogrankings
blogs.botw.org
globeofblogs
readablog

ONLINE MARKETING TACTICS

WEB RINGS

Web rings are a way to have viewers with a common interest find sites covering this subject. For instance, if you are an equine artist, you might want to join a web ring for horse enthusiasts. Since each person's site in the ring is linked to the next, you can visit hundreds of sites on the same topic (and possibly exchange links) as well as drive more people to your web site. Try www.webring.org.

AMAZON.COM

▸ Create a book list related to your style of art—"My Top10."

▸ Review books on your area of expertise.

LISTINGS

List your events on other sites that have calendars and event listings, i.e., your local art organization. Also try:

| craigslist | laughingsquid | artline | flavorpill |

PAY-PER-CLICK

The purpose of a pay-per-click ad is to have your site listed at the top of a search engine. Generally a "click" costs 5-10¢, sometimes as much as $1-5. At Google Adwords, you can limit your budget to any amount you want per month. Google will stop listing you after you have arrived at that budgeted amount. Google explains all their policies online at www.google.com.

CONTESTS

The main idea of having a contest is to gather new names—new potential clients. Make it a requirement that a participant leave her e-mail so that you can promote to her in the future.

▸ Let people who have previously visited your site find out about your contest via a broadcast.

▸ Have a title contest for one of your new artworks and give away a print of it as the prize. Perhaps holding such a contest on a monthly basis will bring clients back.

TEASERS

Post something on your home page to entice visitors to come back.

▸ Going to interview a famous artist soon? Note that on your home page so people will bookmark and come back to read your interview.

▸ Planning to write about a particular topic next quarter? Invite visitors to your site by asking them what they would like to learn about.

GIFT CERTIFICATES

Offer an online gift certificate, which your patrons can purchase for a friend. Send it to them via e-mail or snail mail. Create a system of numbering your certificates, and be sure to keep track of them on a sheet in your office. If two certificates come in with the same number, you should be alerted that something strange is going on.

ARTICLES

Write an article that will attract art collectors to your site. Focus your marketing efforts on getting various sites to carry these articles. Your article's title may sound like these:

▸ 7 Steps to Enjoying Your Purchased Artwork

▸ Suggestions for Displaying Your Artwork

▸ Developing a Sculpture Garden

For example, if you are an abstract painter, write an article about your philosophy on viewing abstract art. Submit it to a site—architectural magazine, interior designer, etc.—and see if they would like to use it. If they post the article, make sure there is a link to it from your site.

Try these sites for article submissions:

artaffairs absolutearts published

newsletteraccess ezinearticles.com

Then go to www.helium.com. Here you can post information and actually get paid for it, as well as spread the word about your expertise.

SEARCH ENGINES

Ninety-eight percent of all searches made online use four main search engines: Google, Yahoo, MSN and Ask. To list your site with these search engines, you will only need to go to two places:

▸ www.dmoz.org - When you submit your information to this site, all the other search engines will pick it up.

▸ www.yahoo.com

PRESS

Post press releases on your site.

ART SEARCH ENGINES OR ART DIRECTORIES

An art directory is a search engine with art-related topics, including names of artists. This is where you want to be listed. Below is a list of not-to-be-missed art directories in which to list your URL. Most are free.

artincontext.org	artsearch.us	artsearch
artline	artareas	art5
dart.fine-art	onlineart	wwar

PRESS LISTS

In order to get placed in a publication, off- or online, your press release will need to present a very unusual perspective. Make sure the title of the press release (and thus the subject line on your e-mail broadcast) captures the most important aspects of the event and that the title evokes interest. (See more about creating press releases in *Art Marketing 101* available at www.artmarketing.com).

▸ Artist sculpts figures from ice

▸ Artist helps raise $20,000 for animal shelter

▸ *New York Times* raves about artist

Sending out thousands of e-mails to a purchased press list doesn't usually work if you don't have the right project to attract attention. When you do have that original art project, contact one of the art-related media:

artforum	e-flux	itsliquid

Download *9 Ways to Write PR*, a free tutorial from www.publicityhound.net.

SECURING RETURN VISITORS

Why would someone want to return to your site? You need to answer this question!

For a person to want to return to your site, she would have to be very interested in your artwork or something else on your site. A return visitor indicates a lot of interest. Here are a few strategies to get return visitors:

▸ Make it easy for them to link back by signing up on your guest book so you can send them reminders.

▸ Update your site monthly with interesting information about you, the art world in general, your travels related to art, etc.

▸ Recommend and review art-related videos, using your original writing style.

▸ Write an artistic critique on art books. Add other people's comments as you receive them by mail (or, if you have a savvy site, enable them to add their own reviews).

▸ Every month, offer a special price on one original piece: first come, first served. Let it be known on your entry page that you do this.

▸ Have a monthly contest. Do something consistently and people will come back.

▸ If you auction on eBay, let visitors coming to your site know this fact.

▸ Offer something free: a free print with the purchase of an original, etc.

▸ E-mail your guest list, informing them of the completion of a new piece.

▸ Ask visitors for an opinion: Do you prefer artwork #1 or artwork #2?

▸ Having a calendar of events on your site can bring people back. You can download calendar forms at www.mattkruse.com or www.cgi-world.com/calendar.html to upload and use at your site.

▸ Have a title contest. Ask your visitors to suggest titles. The one you choose will win a free print.

▸ What do you do best outside of art? Travel? Add that to your site and make that an interesting page to return to. Note artistic places of interest to visit. Include some great photos.

▸ What are your special talents? Do you like to relax by cooking? Then have a link to your page of special recipes, and update it (keeping a back file too). It's okay if you entice them with something that's not specifically related to your art. Maybe it's for your recipe and that yummy-looking picture you posted of it and/or the inventive title: Sam's Monet Delight.

▸ Create a calendar of events of major art shows, specialty art shows, openings of interest, etc.

▸ Tell a story on your site, unique to you, and unforgettable!

Remember, for a visual artist, quantity of visitors is not the point: Quality of visitors is more important.

- ▸ Use a photo of you creating on your next e-mail broadcast. Post it on your web site too.

- ▸ Have an artwork on your home page that notes "Sold" on it. A sold sign is always impressive and evokes urgency to get another piece before someone beats them to the punch.

TRACKING VISITORS

Have a tracking system to see how many people have visited your web site; whence they came can be helpful. By reading reports (which can, at first, seem as foreign as your first financial statement), you will be able to modify your design, meta tags and keywords to become positioned correctly to get the best traffic to your site.

You can even find out which of your web pages a visitor came to first (and maybe think about improving that popular page) or what search engine they used. Make sure that your ISP host can track visitors in the above manner.

You will want to find out:

- ▸ Number of hits per page, showing you which are the most popular pages

- ▸ Number of visitors per day

- ▸ What links are not linking properly (i.e., a 404 error message occurs)

- ▸ Where the visitors are coming from: a reciprocal link, a search engine, etc.

www.internet-tips.net has articles about how to improve your Internet savvy.

If your ISP doesn't have a stats page, use one of the following sites: www.counted.com or www.freestats.com. Several also have counters that you can add to your site. A counter is a box that notes in full view of all passing through your site, how many visitors you have received.

HOW WELL HAVE YOU PROMOTED YOUR SITE?

"Ranking" is the buzz word noting the placement of your URL on a search engine. When someone does a search for your art, do you show up at the top of the list in the search? You don't need to be #1 on the list to have the searcher click on your link, but it certainly helps. With so many artists on the web, however, being #1 can be a difficult goal. That is why you have to figure out what is different about you, your art and your site that can attract people. You can then use that as a lure to show your artwork to them.

There are companies that create their income from promoting sites: making sure your meta tags are okay, making sure your site has been found by the search engines, and even guaranteeing that you will be #1 in the search engines. If you do your job right (and you are the best one to do it), you won't need those companies.

For a fee, however, these companies will assist you with different parts of your promotion. If you don't have the time, these services can fit the bill.

freewebware	ineedhits	isubmit	selfpromotion
submitplus	virtualpromote	website-submission	

BRANDING

As with brick-and-mortar promotion, you need to keep in mind the idea of branding your work. The best way to learn how to do that is to read *Branding Yourself Online* by Bob Baker, a thorough resource to get you going the right direction.

Promote your site off-line —via postcards, telephone calls, invites—to former and existing clients.

Tracking Your Website Visitors by Chris Maher can be accessed at www.lx.comadvisor/maher12.htm.

ACTION PLAN

- ❑ Make a list of appropriate sites and e-mail them to see if they'd like to reciprocate links.
- ❑ Search for some web rings that suit your genre of art.
- ❑ Develop a strategy that will bring visitors back.
- ❑ Write an article for use on other sites.
- ❑ Submit your site to dmoz.org.
- ❑ Learn to read your stats report.
- ❑ Find out where you rank in the search engines.

RECOMMENDED READING

101 Ways to Boost Your Web Traffic by Thomas Wong

Getting Hits: The Definitive Guide to Promoting Your Website by Don Sellers

Guerrilla Marketing Online Weapons: 100 Low-Cost, High-Impact Weapons for Online Profits and Prosperity by Jay Conrad Levison

Increase Your Web Traffic in a Weekend by William Robert Stanek

Increasing Hits and Selling More on Your Website by Greg Helmstetter

Internet for Dummies ???

Internet Publicity Resources by Steve O'Keefe

Maximize Website Traffic by Robin Nobles and Susan O'Neil

Planning Your Internet Marketing Strategy by Ralph E Wilson

Search Engine Optimization for Dummies by Peter Kent

Website Stats: Tracking Hits and Analyzing Web Traffic by Rick Stout

Chapter 7

Selling Art on eBay

by Susan F Greaves

Never pass up an opportunity, nor put it off until tomorrow.

INTRODUCTION

The knowledge in this chapter will cut your eBay learning curve considerably. I'm confident that you will have great success with this head start that I am providing for you, something I wasn't fortunate enough to have.

High-quality canvas panels differ from the canvas boards sold in most art supply stores. Canvas boards have a pressed cardboard backing and deteriorate. The high quality canvas panels are made with cotton or linen canvas adhered with archival glue to masonite or malomine and go by the brand name Raymar. Go to www.raymarart.com to find various sizes of rigid canvas panels.

In March 1999, I began putting my work on eBay, hardly believing that anyone would buy art from a computer screen. By the end of seven months, I had sold over 125 paintings at an average of $240 per piece to collectors and dealers from California to Florida and even in Germany and Portugal. That created $30,000 in sales of original work from my 25-year accumulation of paintings. The sizes ranged from 8x10" to 36x48", priced according to size, starting with $85 for the small to $800 for the larger, unframed. Most were canvas on stretcher bars. (For ease in shipping, I now use high-quality rigid canvas panels.) Soon, I began telling artist friends of my good fortune and showing them how to auction their work on eBay.

Study listings of other successful artists on eBay. You'll find many ideas for presentation and strategy. Look through the current list in the art category. Look at the auctions of sellers who are getting bids, especially higher bids. Look at their ended auctions and final bids. Observe what size work they are selling and what upgrades they are using. To get this information on eBay, go to Advanced Search/ Search by Seller at the top of any eBay page. Next, select Search by Seller on the menu on the left. Enter the Seller's ID and select "30 days" and "include completed auctions." Then hit Search.

My daily time presently spent working on eBay is two to three hours. It is spent corresponding with eBay buyers and prospects, preparing images, listing auctions, printing handouts that are included in each shipment, and preparing packing slips and shipping labels.

One artist on eBay has an assistant who handles her paperwork and shipping so that she can paint and produce even more to auction on eBay. She has sold as much as $30,000 per month and has about $6000 in expenses. That's a nice net! I've used a lot of her ideas, which she kindly shared with me, and now I'm passing them along to you.

As eBay has evolved from a small company searching for effective ways to connect sellers and buyers into an Internet power, the art category and its audience has continued to grow and change. The costs to list have increased, but the distinct advantage of selling on eBay remains—tens of millions of viewers. When combined with other online opportunities, like web sites and blogs, selling on eBay still generates the most sales activity for artists on the web.

SELLING ON EBAY IS DIFFERENT

Nothing compares with the audience of over 30 million registered on eBay. Many eBay users perusing the fine-art listings are art dealers. In addition, many people who eagerly search through the eBay listings of art have never set foot in a fine art gallery, and probably never will. Apparently, eBay is less threatening. Selling to those individuals builds the future of the fine art market.

ARTWORK WORKSHEET

Print thumbnail image of artwork here

Print PayPal packing slip here

Artwork Title _____

Size _____ Medium _____ Starting bid/eBay price _____ Retail price _____

PayPal net _____ PayPal fee _____ Date shipped _____

Paste shipping label record here or staple receipt to this form

Photocopy this for your own use.

Invoice sent _____
Payment rec'd _____
Shipped_____
Feedback rec'd _____
Feedback given_____
Sale recorded in inventory_____
Posted to acctg program _____

The psychology of selling artwork in Internet auctions is very different from the established gallery system you may be accustomed to. You will be aiming for volume, not high prices.

WHO HAS THE BEST FIT FOR SELLING ART ON EBAY?

▸ Helps to be familiar with the computer

▸ If you are selling at a high-end gallery, most likely you do not need to use eBay to add to your income.

▸ If you are an emerging artist relative to exhibiting your work, eBay could be the perfect venue.

HOW THE AUCTION PROCESS WORKS

▸ First, you prepare images of your artwork. You will learn in detail how to do that, including all the choices available, and various costs of each.

▸ Next, you fill out an Artwork Worksheet for each artwork (see previous page) where you can record each artwork's progress.

▸ Then, you submit the artwork to eBay.

▸ Lastly, you complete post-auction activities, including collecting payment from the buyer, shipping the work and putting the item on auction again.

PROS AND CONS OF SELLING ON EBAY

▸ Expect to save lots of time and money by not framing, not mailing invitations, not paying for receptions, no hanging, no packing (I recommend that you use a shipper, especially at first), and no paying for shipping to and fro.

▸ Expect to see your work grow because you will have time and motivation to create. That's the best "pro" of all!

▸ In exchange for bypassing the middle man, the buyer expects near-wholesale prices. Most of your sales will be to art dealers, so your work ultimately will enter the market at retail. Be humble. You'll gain!

▸ Do not expect to sell every artwork the first week it is placed on auction. It may take several weeks for the right work, the right buyer, and the right price to come together.

▸ When you start, do not expect bidding to go a lot higher than your minimum starting bid or reserve amount. In time, bidders will look for your work and more bids will be placed.

Stay focused! You will be tempted to try every Internet offer that comes along. Other than keeping yourself informed about eBay changes and events (such as days for reduced-price or free listings), use your time to produce artwork, not to chase rainbows.

You will need a working vocabulary to start to sell on eBay, provided for you on the next page.

About Me and My eBay World pages – eBay started with the About Me page and, I think, is transitioning sellers to the My eBay World page. This is space on the eBay site, separate from your seller list and item description pages, that eBay provides for you to tell your customers about you and your business. Make your page unique and interesting. The rules about what you can put on these pages are much more lenient than what you can put in your item description. Put links to your blog and/or web site, and encourage sign-ups for your e-mail list.

Auctions and eBay Stores – These are interconnected sites, two methods by which eBay presents items to buyers. You must pay a monthly fee—about $15.95—for an eBay Store. Store listings and fixed-price eBay listings are also shown on another site called eBay Express, which caters to buyers who want to make immediate purchases, more like other shopping sites on the Internet. This cross-promotion can bring more buyers to you. Auctions, however, give the most exposure on eBay.

Categories – eBay divides items into categories. The art category is subdivided by period, subject matter, and more.

EBay Express - A store listing, auctions with the Buy It Now option, and fixed-price eBay listings are also shown on this site. It caters to buyers who want to make immediate purchases. This cross-promotion is done automatically and can bring more buyers to you.

Feedback – Feedback is a statement that people who have interacted with you on eBay —whether buying or selling—submit to eBay regarding any business transaction with you. A feedback log is created for anyone to view. This is the only way future buyers will know that you are a responsible businessperson. I recommend that you have at least 10 positive feedbacks from purchasers before you start selling on eBay. Having 20 positive feedbacks allows you to open an eBay Store (discussed in this chapter).

Gallery – When shopping, buyers on eBay can look at lists of auction titles, with tiny pictures, or at the gallery view, which has larger images. For artwork, the gallery option is a must for each listing.

Hits – The number of times people view your item page

JPG – a commonly used, standard method of compression for digital images

Listing upgrades – For an extra charge, you can place your listings in a more conspicuous location on the eBay category lists and search results.

Listings – These have information about each item offered for sale on eBay. eBay provides several ways to participate; one- to 10-day auctions; Fixed Price listings; and Store listings.

Keywords – like search words. They are words people enter into eBay's search boxes to find items that interest them.

EBAY GLOSSSARY

Refer to this glossary as you read the rest of this chapter.

PayPal – The eBay-owned payment service. PayPal accepts credit cards for you for a small fee. The advantage to you is that customers can purchase using PayPal from your blog and web site, as well.

Photo hosting service - a site, such as www.villagephotos.com and www.photobucket.com, where you can upload and store photo images for a fee. Your Internet Service Provider may offer this at no extra charge.

Reserves – If you have participated in art auctions, this is a familiar term. On eBay it works the same way. A reserve is the amount below which you will not sell. It is always higher than the starting bid.

Search words - see Keywords.

Second Chance Offer - If a winning bidder decides not to complete the purchase, you can offer the artwork to the next highest bidder through eBay. This feature is also useful if the bids do not reach the reserve amount, and you are willing to accept the near-reserve bid.

Sell Your Item pages – This is where you enter your Master Auction Description and other information about the artwork.

Seller ID – Same as User ID. Be sure to choose an ID that is easy to remember, will let customers know what you do, and if possible has your web site name.

Seller list – This list contains only the items you are selling. People get to this list by searches, links on your item pages, their personal "favorites" list on eBay, or links outside of eBay, such as your web site. You want people to see this list so they see all of your listed artwork, not just one piece from the list of thousands of artworks in the art category.

Shipping calculator – An option on the Sell Your Item/Payment and Shipping page that can be inserted into an auction listing. It is a way for the prospective buyers to see what the shipping charge would be from your location to theirs.

Starting bid – The price at which the bidding begins. You can put the amount you want for the piece without a reserve or you can put a lower amount. Lower amounts always get more hits.

User ID – Your "name" on eBay (see Seller ID)

STEP I - ORGANIZE YOUR COMPUTER

Set up folders for your eBay activities.

▸ Create a new folder on your hard drive and name it eBay.

▸ Open the folder.

▸ Create seven new folders within the first, titling them:

Images to prep

Prepped images

Statements

Descriptions

Mailing lists

Form letters

Forms

STEP II - CREATE A RECORD FOR EACH ARTWORK

Photocopy Artwork Worksheet on page 83 several times. (You can view a copy of one that has been filled out on page 101.) Fill out one form for each artwork you will be auctioning. These forms will go into a notebook described in Step VI.

STEP III - PREPARE IMAGES OF YOUR ARTWORK

▸ Photograph artwork you intend to auction.

▸ Transfer these images to your Images to Prep folder on your computer.

▸ Prepare your images and save them in your Prepped Images folder.

▸ Using your picture editing program, print a thumbnail image of the work in the rectangular area of the form on page 83. This will be the record for that artwork throughout its life on eBay.

PREPARING IMAGES

Digital Cameras - Images from a digital camera are the easiest way to get your art to a computer and then to eBay for auction. If you do not have an adequate digital camera, buy one on eBay. You'll build some feedback that way.

Scanned artwork - If your artwork is two-dimensional and small, you can scan it

THE SIX STEPS

eBay offers great info on uploading pictures. Click on Help at the top of any eBay page and enter "add pictures" in the search box.

Take your photos, slides or digital images in sunlight or under color-balanced light. This will save you many reproduction headaches. If you are selling a framed piece or three-dimensional piece, shoot it against a plain background or drape.

with a flatbed scanner ($50-75). Use the highest resolution possible. Place the scans in the Images to Prep folder.

Photographs - Use a flatbed scanner to scan photos of your artwork onto your computer. Save the scans in your Images to Prep folder. Alternatively, you can take the photos to Kinko's or a service bureau for scanning. If you take new photos of your work, most film processing services will put the images on a floppy disk or e-mail them to you.

Slides - Use a flatbed scanner with a slide adapter, or use a slide scanner. Alternatively, take the slides to Kinko's or a service bureau to get them transferred into a digital format. If you already have an extensive collection of slides of your work, an excellent buy is a Hewlett-Packard S20 slide scanner. Used ones are available on eBay for about $250. Next to a high-resolution digital camera, this gives the best images. To learn about this slide scanner, go to www.shopping.com, www.hpshopping.com, www.buy.com or www.eBaycom.

IMAGING PROGRAMS

Decide what software imaging program you want to use. Your computer may have come with one already installed or your digital camera package may have provided a program disk. If it is easy to use, do so. The adjustments you have to make to your images should be simple (assuming that you have taken them in good light), so a basic software imaging program will suffice. Your choices are:

▸ Use the program that came with your digital camera or computer.

▸ **MGI PhotoSuite** - The simplest version will do and it is inexpensive at $29.99. www.roxio.com/en/products/index.html

▸ **Paintshop Pro** - A simplified, less expensive version is available at $99 or less. www.paintshoppro.com.

PREPPING YOUR IMAGES FOR AUCTION

▸ Save each image as a jpg file. Title the file in lower-case letters without any punctuation or symbols. It may be helpful to include the dimensions of the artwork: eveningintheforest11x14.jpg.

▸ Crop the image, eliminating the background if it is a two-dimensional piece.

Always use the highest resolution your camera allows.

▸ Resize the image. This will allow the image to fit the screen and load quickly. Maximum height should be 375 pixels; maximum width 450 pixels (eBay's instructions are in pixels, not inches).

▸ Adjust the image color if needed. Be sure the contrast is good and the colors are bright.

▸ Save it in your Prepped Images folder.

STEP IV - PREPARE MASTER AUCTION DESCRIPTION

To get your auctions up and going, use this outline to prepare a simplified description. Your first master auction description will include:

- ▸ Your name
- ▸ Tag line
- ▸ Artwork title
- ▸ Statement about each artwork
- ▸ Bio and general description of your art
- ▸ Payment, shipping and guarantee

YOUR NAME

Do not vary your name—for example, from Susan Greaves to S. Greaves to Susan F Greaves. That would create havoc for people who want to locate your work. In all usages of your name, be consistent. Using the name that will be on buyers' receipts is a good idea.

Conversely, be sure that the text of all of your online materials, including your Master Auction Description, contains all forms of your name so that buyers using a search engine or the eBay search function can find your work no matter what form of your name they enter into the search engine.

Your name is your brand, so it is important to be consistent in its use.

TAG LINE

A tag line is similar to a slogan—for example, "The Un-cola." The tag line, along with the logo and company name, helps define your product. (Yes, your artwork has become a product if you are selling it.) A tag line should note the physical features of your artwork, the emotional aspects and the special qualities. As an artist, you also want your tag line to help define the style and/or subject matter of your artwork. For eBay purposes, your tag line should include words that can be picked up by eBay's search function—five to six words is good. Use keywords, also called search words, such as painting, sculpture, contemporary, abstract, etc.

SAMPLE TAG LINE

JOYFUL PAINTERLY REALIST ORIGINAL OIL PAINTINGS

ARTWORK TITLE

- ▸ Original title (in italics) of your piece

- ▸ Final image size (height, then width)

- ▸ Proper way to write the size: 9x12″, not 9″ x 12″; note, only one inch mark and no space between number and X.

- ▸ Medium

- ▸ Material onto which it is placed, such as canvas or paper

- ▸ Framed or unframed

SAMPLE TITLE

Bridge to Mystery, 9x12″, oil on stretched canvas, unframed

STATEMENT ABOUT EACH ARTWORK

Your statement is key to the effectiveness of your ad.

For each artwork, prepare a short statement using your favorite word processing program. It should focus on why you created this piece, your inspiration, where you created it, how it relates to the rest of your work, and any personal experience about it. Personalize this statement, giving the buyer something to associate with emotionally. Also mention the gallery price (the price at which your brick-and-mortar gallery would retail your work) and the shipping charge. Save each description in the Statements folder under the title of the artwork. By including the retail price and the shipping charge here, the only editing you will have to do for future auction descriptions will be to replace this paragraph.

SAMPLE STATEMENT

I painted this in the shade of trees covering Rio Ruidoso in New Mexico during one of the Alla Prima International's painting events. The darks gave a sense of mystery while the evening sun lit the bridge and the spring leaves. The gallery retail price for my work this size is $350. Shipping by Priority Mail is $6.

BIO AND GENERAL DESCRIPTION OF YOUR ARTWORK

Compose a short biography and general description of your work. The biography should be no more than six to eight sentences and should summarize your training, shows, competitions and awards. The general description of your artwork should be three to four sentences and may include subjects, style, motivation, etc. Name these statements "Bio" and save in the Statements folder.

SAMPLE BIO

It has been my pleasure to sell over 500 of my paintings on eBay under User IDs greavesart, pitchfordart, and sfgfineart. (Please read my feedback.) I have been painting for over 30 years and my work has been recognized across the United States with more than 50 awards. I have been elected to signature membership in Knickerbocker Artists and Alla Prima International and Master Signature status in Plein Air Painters Northwest Society. On eBay, I offer original oil paintings of plein air landscapes, floral and still life, portraits, figurative, and equine art, which are most appropriate for home and office settings. Described by others as impressionist, painterly or realist in style, my work is always colorist in attitude. Color is my delight and is the means I choose to convey both the mood of the painting and my philosophy.

PAYMENT, SHIPPING AND GUARANTEE

Use the next paragraph of the master auction description to state particulars about payment, shipping and your return policy.

▸ Note what types of payment you will accept: PayPal, checks, money orders, etc.

▸ Note that you wait for checks and money orders to clear before shipping—seven to 14 banking days.

▸ Note that the buyer pays for shipping, packing and insurance. Offer combined shipping for multiple purchases.

▸ State the cost of shipping for each piece. Some eBay sellers inflate the shipping fees to increase their profits. Bidders, of course, don't like this and consequently, want a fixed amount before bidding, or assurance that they pay the actual cost of shipping and not an inflated "handling" fee. Alternatively, you can set up the eBay shipping calculator.

▸ Offer a liberal return policy and guarantee. Statistics confirm that the number of returned items is actually reduced with such a guarantee.

▸ Include international sales information. International buyers pay all custom fees, duties, and taxes (explained further on in chapter).

▸ Save this paragraph in your Statements folder.

Buyers on eBay love PayPal because they feel more secure using this intermediary than they would by sending a check to an unknown person. Also, their merchandise can be shipped sooner.

I accept checks, money orders, or credit cards via PayPal. Please allow time for checks and money orders to clear the bank, approximately 7 to 14 banking days. Buyer is responsible for costs of packing, shipping, and insurance. I will combine shipping for multiple purchases. 100% Money Back Guarantee. Returns of undamaged artwork accepted within 30 days of receipt. Buyer pays return shipping and insurance. International buyers pay all customs fees, duties, and taxes. Contact me for international shipping charge. Thank you for visiting my auction.

ASSEMBLING YOUR MASTER AUCTION DESCRIPTION

▸ **Your name** goes first

▸ **Tag line** next

▸ **Artwork title** on third line

▸ Copy and paste **Statement about specific artwork** here.

▸ Copy and paste **Biography and general description of your artwork** here.

▸ **Payment, shipping and guarantee** goes last.

EXAMPLE OF COMPLETED MASTER AUCTION DESCRIPTION

<div align="center">

Susan F Greaves

Joyful Painterly Realist Original Oil Paintings

Bridge to Mystery, 9x12 "

oil on stretched canvas, unframed

</div>

I painted this in the shade of trees covering Rio Ruidoso in New Mexico during one of the Alla Prima International's painting events. The darks gave a sense of mystery while the evening sun lit the bridge and the spring leaves. The gallery retail price for my work this size is $350. Shipping by Priority Mail is $6.

It has been my pleasure to sell over 500 of my paintings on eBay under User IDs greavesart, pitchfordart, and sfgfineart. (Please read my feedback.) I have been painting for over 30 years and my work has been recognized across the United States with more than 50 awards. I have been elected to signature membership in Knickerbocker Artists and Alla Prima International and Master Signature status in Plein Air Painters Northwest Society. On eBay, I offer original oil paintings of plein air landscapes, floral and still life, portraits, figurative, and equine art, which are most appropriate for home and office settings. Described by others as impressionist, painterly or realist in style, my work is always colorist in attitude. Color is my delight and is the means I choose to convey both the mood of the painting and my philosophy.

I accept checks, money orders, or credit cards via PayPal. Please allow time for checks and money orders to clear the bank, approximately 7 to 14 banking days. Buyer is responsible for costs of packing, shipping, and insurance. I will combine shipping for multiple purchases. 100% Money Back Guarantee. Returns of undamaged artwork accepted within 30 days of receipt. Buyer pays return shipping and insurance. International buyers pay all customs fees, duties, and taxes. Contact me for international shipping charge. Thank you for visiting my auction.

Save this Master Auction Description in your Descriptions folder and lock it. To lock it, open the folder and highlight the name of the document. Right click and select Properties. Beside Attributes, select Read Only.

STEP V - SUBMIT ARTWORK AND START AUCTION

▸ Register as an eBay user. Go to www.ebay.com. Click on Register Now. Follow the instructions. Unless eBay has changed its procedure, you will receive an e-mail and Seller ID. Change this Seller ID to an easy-to-remember word that includes your name and indicates what you do, like "greavesart." If you have a web site, use your domain name or a form of it.

▸ Provide a valid credit card to eBay for the auction listing charges and

commissions. Select eBay Site Map at the top of any eBay page. Under SellerAccounts, choose "Place or update my credit card."

▸ Go to eBay's Sell Your Item page (click on Sell at the top of any eBay page). Follow instructions, filling text boxes and selecting options after referring to the following notes.

CATEGORY

Under First, choose a main category. Click Art and select appropriate subcategories. Choosing a second category is optional. It doubles the costs but increases the exposure. Some types of artwork should be offered in categories other than the art category, such as art note cards. I list my equine paintings in both the art category and the equine sporting goods category.

WAYS BUYERS FIND YOUR ARTWORK

Category list – An eBay buyer may click on "Art" in a list of the main categories of items listed on eBay. This list shows the titles of all of the listings and thumbnail pictures.

Gallery view – A buyer may choose gallery view to view items from a page with larger pictures of items. This view will show the image you submit as Gallery Image on the Sell Your Item pages or will default to the image you submit to Basic Picture Services if you specify the Gallery upgrade. (More about this later.)

Seller list – A buyer may go directly to a page that shows only the items you are selling by selecting your seller list from their favorites list or entering it in Search by Seller.

ITEM SPECIFICS

Select the appropriate Item Specifics for each category. Vary them occasionally in other listings to snag more buyers. I vary mine from Impressionist to Realist to Abstract, when applicable.

PICTURE SERVICE

Choose Basic Picture Services. Hit Browse and select your artwork image and upload.

AUCTION TITLES

The Auction Title is the listing title that eBay buyers see in the category list, seller list, or search results along with a thumbnail picture. This title is limited to 55 letters and spaces. As the number of listings in the art categories swells, most bidders use the search feature to find listings for artwork that interests them. Hence,

it is imperative that you use the correct terms in the auction title to bring prospects to your auction.

Auction titles used on eBay are not the titles you have given your artwork for your gallery. These titles do not appear in your master auction description.

To research the best and shortest form of your own name to use in your auction's title, since it sets you apart as an artist, enter your last name in any eBay search box. How many items turn up? If there are many, try your initial, a space, plus your last name or some other variation of your name (S Greaves, Susan G, SF Greaves, or just Greaves). Place the version that shows the fewest listings in your auction titles so buyers will not have to go through a long list of search results to find your auctions.

I found that searching for "Greaves Art" was the best way to find my listings because I use "art" in most of my listing titles. Thus, I note "Search for Greaves Art" on my promotional materials, as well as on my business card.

Remember, the auction title does not have to read like a sentence, so you can leave out prepositions and articles.

Vary your titles from auction to auction. Do not use the same group of words for every artwork you list.

Include as many of the following as possible in your title. These are in order of priority:

- Artist's name (in that short form you just researched)

- Original, print or multiple

- Medium

- Subject matter; genre/style

- On canvas or on paper; framed or unframed

- General size; miniature, small, large, huge

- Predominant color

Capitalizing some of the words in the title makes it more eye-catching. Your auction will stand out in those long lists of artworks in the category list.

Capitalize some words to catch the bidder's eye.

A Dutch Auction is a multiple-item auction, i.e., if you are selling more than one of any given item, such as prints or other multiples.

FOUR EXAMPLES OF AUCTION TITLES

Greaves Still Life Roses Oil Painting Original

Greaves IMPRESSIONIST ART Plein Air Oil Painting TAOS

Plein Air Oil Painting Listed Greaves GARDEN Signed

Greaves OIL FIGURE Painting Woman Original Realism

You can revise or edit your listings when no one has bid if you have more than 12 hours remaining.

SUBTITLE

A subtitle can give more specific details about the work, use humor, be mysterious, spur curiosity and so on. Using a subtitle is an option. It can catch the bidder's eye as he goes through the long menu of listings. Use the chart of descriptive words on page 102 to generate ideas.

SUBTITLE EXAMPLE

#5 of Limited Edition of 300 – Provence Series

DESCRIPTION

Copy and paste the Master Auction Description. Substitute the statement about each specific artwork in the first paragraph.

QUANTITY

Leave quantity as 1. Select Dutch Auction if that is appropriate.

STARTING BID AND RESERVE

Put the lowest amount you will take for your artwork as the starting bid. This should be about one-third of your retail price. (Remember all those cost-savings you will have that make this possible.) For example, if the gallery retail price for a piece is $350, your starting bid should be about $135. For this, you would not use a reserve amount.

If you want more eBay bidders to visit your auction page, put your starting bid very low—$7. More people look at the low-priced auctions. Often, a bidding war will start and the bids will climb above what you would have otherwise set as your starting bid. Also, from your auction page, they can click on a link and visit your other auctions. There's more of a chance that they will fall in love and bid or buy.

AUCTION DURATION

Set the Auction Duration as seven days.

PRIVATE AUCTION

Leave Private Auction unchanged. Use this feature only when you do not want a buyer's User ID to appear in the listing or bid history. Normally, it is only used for very high-priced or adult items.

SCHEDULE AUCTION

Schedule your auction to start (and, therefore, end) when most buyers are likely to be online—weekends and weekday evenings in prime time, 7-10 PM.

LISTING UPGRADES

Upgrades (see page 85) are optional but advised if your budget allows. These will hasten the time when you start making sales. Select Featured Plus for the better placement in category lists and search results. This costs an extra $19.95, but you will not be adding this to all of your auctions.

Some upgrades work better than others. I've had the most success with Featured Plus, Gallery, and ProPack. See the Sell Your Item/Pictures and Details page for specifics.

Gallery is an upgrade that places a small image beside the auction title and a larger image in the Gallery view, which bidders may choose when looking for items. For artwork, gallery is a must.

COUNTER

Select Add a Counter. The counter that will appear at the end of your auction page will show you how many eBay buyers have been interested in your item and viewed your auction page. Use this number to test the effectiveness of your title, subtitle, gallery image, and upgrades.

SHIPPING COST

Select Buyer Pays Actual Shipping Cost. It is best to have a set shipping amount per size of artwork or choose to display eBay's shipping calculator in your listing. On the Sell Your Item/Payment and Shipping page, choose the Calculated tab and enter the information requested. This will allow bidders to see what they would pay based on their location.

I use Priority Mail since the cost is low and fixed. Therefore, I can send domestic shipments of my flat canvas panels for $6 to $10, depending on size. You can design your new artworks to be shipping friendly.

As you are doing your research at the post office, note the difference in price between "Flat Rate" Priority Mail and plain Priority Mail. Shipping can be kept to $4.05 or $8.10 (at Flat Rate). Purchase $4.05 stamps from the USPS to keep on hand. You also might want Delivery Confirmation forms.

The essential time-management principle is to "keep it simple."

SHIPPING DISCOUNT

Select to Combine Shipping on Multiple Purchases.

PREFERENCES

Select Remember My Selling Preferences.

Proofread everything carefully. Once everything is perfect, hit Submit. When the auction starts, you will get a confirmation e-mail from eBay.

If you realize later that you have made a mistake, you can revise your listing by going to your My eBay/All Selling page and click on the drop-down list beside the auction title. Select revise. The revision pages look very much like the Sell Your Item pages, except that the information you have entered is filled in.

STEP VI POST AUCTION

Get organized by using a three-ring binder with the following divider labels:

Sold - artwork that has been sold and is in the follow-up mode

Listed - current auctions

Not Sold - artwork that has been up for auction but not sold and will be relisted

New - artwork ready to list

To Prep - artwork for which images and auction are being prepared

Hold - artwork set aside to list as part of a promotion or for other reasons

The worksheets will normally move from back to front. Any worksheet that is moved should be placed at the back of its section.

POST OFFICE SHIPMENTS

Keep the sizes of your artwork standard and you will have a lot fewer headaches. It will also make it easier, as well as less expensive, for the purchaser to frame them.

▸ Go to your local post office and learn all you can about Priority Mail: Flat Rate costs, box sizes, insurance costs, Delivery Confirmation, etc. The post office is by far the least expensive way to mail. They also pick up for free.

▸ When you find out what size packages are convenient and inexpensive to use, start purchasing the appropriate size of rigid canvas panels to fit. Since you don't need to weigh a Flat Rate Priority package, stamps keep shipping simple.

▸ You can get an account with USPS online. When you arrange for a shipment online, they will include free Delivery Confirmation.

UPS SHIPPING

▸ If UPS is a convenient way for you to ship, get an account and use their online services. You will also be able to print and tape your mailing label to the package.

▸ Use UPS to ship artwork larger than 16x20″; pack it between corrugated board for a bit more protection. Since it is too large for Priority mailers, be sure to allow for this extra packing cost when you note the price of shipping on your Master Auction Description.

TIPS

→ Both USPS Priority Mail and UPS can be paid for via PayPal online. Shipping labels can be printed through your PayPal account. The PayPal shipping label also has a small receipt, which is a record of the shipment, complete with a tracking number. Cut this out and attach it to the artwork worksheet.

→ Always purchase tracking or request Delivery Confirmation; it is considered part of the shipping cost, and thus the purchaser pays. If a package is late, you can give the buyer a tracking number and she can view on the shipper's web site the status of her delivery.

→ The main difference between UPS and postal Priority Mail is insurance claims procedure. UPS will let you file a claim as soon as you realize something has not arrived on schedule and their tracking says it has been delivered. Priority Mail requires that you wait for 30 days to file a claim (in hopes the item will show up). Delivery Confirmation from USPS has become automatic for Priority Mail if you use their online services. With this service, I have had very few claims.

→ Framed pieces always cost a good deal more to ship. So be sure to calculate all your expenses in so you don't end up taking a loss.

ONLINE SECURITY

In addition to your usual precautions for protecting your computer and your identity—a fire wall, virus protection, spyware detection, and spam protection from your Internet Service Provider—there are a few situations regarding eBay and PayPal of which you should be aware.

SECURITY ON EBAY

Here are some things you can do to avoid most of the headaches that could come with using eBay.

- **E-mail** - Always communicate with your eBay contacts through eBay's message system. Look for Contact Buyer on the item page or go to My Messages from the My eBay page. Choose Find and Contact a Member from the menu on the left.

- Never click on a link and enter your password from an e-mail you receive through your e-mail service, even if it looks like it is from eBay. Many of these are "phishing" e-mails attempting to get your security information. There are many reports of eBay users clicking Respond Now in e-mails they have received and entering their password on the page that pops up. Once you have given your password, the scoundrels can access your account, go on a shopping spree, or steal other identity information.

- **Discussion Boards** - Since most discussion boards online and on eBay are not monitored, or may not be monitored fairly, misinformation and untruths can be posted, sometimes just for the sport of it. Also, posted responses can be selectively deleted to slant the discussion. Participate at your own risk!

SECURITY ON PAYPAL

The same words of caution about bogus eBay e-mails apply to PayPal e-mails, too. Other precautions should be taken with payments and refunds.

- Never accept payment in excess of the purchase.

- Never refund money to a buyer via check or money order if the buyer paid you through PayPal. (Refunding via PayPal will preserve the protections for Sellers that PayPal automatically grants sellers. See PayPal Help for more details.) Go to the Refund Payment link on the Transaction Details page in PayPal.

- print thumbnail above -

PayPal®
Artwork Worksheet
Packing Slip

Ship To:	Pitchford Art	**Ship From:**	Susan F. Greaves
Address:	15742 Middletown Park Redding CA 96001 United States	**Address:**	15742 Middletown Park Redding, CA 96001 United States
Email:	pitchfordart@aol.com	**Email:**	greavesart@aol.com
eBay ID	pitchfordart	**eBay ID:**	greavesart

- print PayPal Packing Slip here -

Transaction ID: 6PG92622GL2139626

Item #	Item Title	Qty	Price	Subtotal
300069971042	GREAVES CALIFORNIA PLEIN AIR LANDSCAPE LAGUNA OIL	1	$191.00 USD	$191.00 USD

Subtotal:	$191.00 USD
Shipping & Handling:	$6.00 USD
Shipping Insurance:	$0.00 USD
Sales Tax (7.250):	$13.85 USD
Total:	**$210.85 USD**
	This is not a bill.

Note: Thanks for paying with PayPal - the safe way to pay online. It was a pleasure doing business with you.

Artwork Title	"Laguna Day"		
Size 11" x 14"	Medium oil	Starting bid or eBay price $225 -	Retail price $770 -
PayPal net 208.60	PayPal fee 2.25	Date shipped 1-3-07	

Invoice sent	✓
Payment rec'd	✓
Shipped	✓
Feedback rec'd	✓
Feedback given	✓
Sale recorded in inventory	✓
Posted to accounting program	✓

- Paste shipping label record here or staple receipt to this form -

DESCRIPTIVE WORDS FOR SUBTITLES

AESTHETIC

creative
musical
poetic

ALLURING

bewitching
desirable
fascinating
fetching
quaint
seductive

APPEALING

charming
elegant
fascinating
graceful
refined

BEAUTIFUL

attractive
glamorous
grand
handsome
radiant

BRIGHT

blazing
burnished
flaming
infused
intense

BRILLIANT

dramatic
enticing
ecstatic
inspirational
radiant
resplendent

COLOR

bright
brilliant
monochromatic
primary

ELEMENTS

contrast
space
texture

ENERGETIC

engaging
mercurial
lively
luminous
sparkling
unfettered
vigorous
vivacious

EXCELLENT

accomplished
distinct
exquisite
first-class
outstanding
premium
select
splendid
superb
superior

EXCEPTIONAL

extraordinary
remarkable
resplendent

FABULOUS

fantastic
marvelous
wonderful

FINE

choice
elegant
pleasant
refined

FORCEFUL

animated
arresting
charismatic

electrifying
sparkling
spirited
vivacious

GLITTERING

dazzling
gleaming

GORGEOUS

comely
wonderful

GRAPHIC

jazzy
lively
rich
static

IMPOSING

striking

IMPRESSIVE

outstanding

LUMINOUS

aglow
beaming
illuminated
lighted
radiant
shining

MAGNIFICENT

exquisite
superb

NICE

admirable
agreeable
delightful
likeable
pleasant
pleasing

PICTURESQUE

scenic

POWERFUL

convincing
imposing

QUALITY

elegant
well-done
uncommon

QUIET

melancholy
moody
tranquil

SINGULAR

exceptional
extraordinary
remarkable

SPONTANEOUS

free
impromptu
unconstrained

STRONG

important
meritorious
significant
worthwhile

SUPERIOR

premium
refined
superb

VIVID

glowing
intense
shining

VIBRANT

active
aglow
dynamic
resonant
upbeat

WHEN YOUR ARTWORK SELLS

On eBay, the My eBay/All Selling page is a one-page central location for management of all your auction activities—monitoring ongoing auctions, tracking scheduled auctions, following post-auction activities for sold and unsold auctions. Click on My eBay at the top of any eBay page. Select All Selling from the menu on the left.

Post-auction steps are represented by entries in the lower right column of the worksheet (page 83). Use your Artwork Worksheet that you have started for any post-auction notes. The large space at the top of the worksheet allows you to print the PayPal packing slip from the PayPal Transaction Details page onto your worksheet. This is a quick and easy way to record the sale. The lower sections allow you to note other details.

You will receive an e-mail reminder when any of your auctions end. Do not respond to this e-mail.

▸ If the artwork has sold, go to the My eBay/All Selling page and choose Send Invoice in the drop-down list beside the sold auction title. Check and revise the figures, if necessary. Be sure you have charged the correct amounts for shipping and tax.

▸ If payment for your artwork is by PayPal, print a copy of their Packing Slip directly on your worksheet. From the My eBay/All Selling page, choose View PayPal payment from the drop-down list to the right of the auction title. Select Print Packing Slip from near the bottom of the page and print to your Artwork Worksheet for this artwork. Here you will find most of the information you will need to follow through on the sale. Be sure to note the net amount of the payment you will receive after the PayPal charges and the amount of the charges themselves (a mock-up is shown on the next page; names have been changed).

▸ If you are not paid through PayPal, go to the My eBay/All Selling page and click on the drop-down list to the right of the auction title in the list of Sold auctions. On the next page, you will see information about the sale, such as whether the buyer has indicated that he will pay by check or money order, his User ID, his name, and his shipping address. Note these on that artwork's worksheet.

If the buyer pays via PayPal, you can ship the work on receipt of payment. (You will be notified via e-mail.) If he sends a check, certified check, or money order, wait until the check clears your bank before shipping the piece.

▸ Check off activities on the lower right side of the Artwork Worksheet. Spaces are provided for other record-keeping activities, such as entering the buyer's name and address in your long-term inventory, asking the buyer if he'd like to be on your e-mail list, and entering the transaction in your accounting record.

WHEN LISTING ENDS

IF YOUR ARTWORK DOES NOT SELL

When you are ready to re-list an artwork, click on the re-list option in the Unsold list on My eBay/Seller page. By using this method, previous bidders and those who have put the auction on their Watch List can find the new listing more easily. Be sure to make changes in the format, and listing upgrades as needed, and check the charges at the bottom of the last re-listing page before hitting Submit so you do not incur unwanted fees, such as an upgrade like Featured Plus.

If you have an eBay Store, place any unsold artwork in your store. List new artwork as auctions. This works best if you have a www.vendio.com gallery, which places images of all of your listings in each auction to draw buyers to all of your listings, whether on auction or in your eBay Store. More about www.vendio.com later.

Watch List – eBay users can flag a seller's list so that they are able to access the list easily from their My eBay page, similar to a bookmark or favorites list.

PRICING TO SELL

Pricing is as difficult to determine on eBay as it is in the traditional market. Staying competitive on eBay demands more flexibility. Find completed eBay listings for work similar to yours. See what they have sold for. Remember, though, that the amount buyers on eBay will pay often depends as much on strategy as on the work itself.

eBay buyers associate price with size. My average starting bid or reserve for an 8x10″ oil painting on canvas panel is $160; 11x14″ @ $225; 16x20″ @ $325.

IMAGE QUALITY MUST BE GREAT

▸ Make sure it is in focus, sharp and bright.

▸ Make sure it represents the true color correctly.

▸ Make sure the image file is a 72dpi jpg no larger than 40KB, enabling it to load quickly.

START AND END TIMES ARE IMPORTANT

Bidders find auctions on eBay in different ways. If they want to see what is newly listed, they will look at the category list that has the most recent items first. If they are impatient and don't want to wait a week or more to win an auction, they will choose to look at items closing soon.

Most private collectors go to eBay in the evenings and weekends. Dealers generally search and bid on weekdays during business hours (in their time zones). If you have a large inventory, it is best to list enough auctions (14 to 21 per week) to spread them through the category list; one morning and one or two evening auctions.

LENGTH OF AUCTIONS CAN MAKE A DIFFERENCE

eBay offers three-day, five-day, seven-day, and 10-day auctions. Try to have an auction ending every day so you will have something near the top of the category lists and search results.

ENHANCING SALES

When you price your work for sale on eBay, remember the costs you will not be incurring—framing, shipping, commissions.

eBay artist Laura Sotka (Seller ID dogartdog) suggests that if you would be happy with the amount of your starting bid, you can start with a three-day auction and extend it to a five-day, then seven-day, and then 10-day auction until you get a bid. This keeps the listing near the top of the category list and draws more hits. My experience is that this works fairly well with Featured Plus and ProPack auctions, but not with regular listings.

The more artwork you produce, the more you will sell.

UPGRADES

eBay requires a feedback rating of 10 to qualify for both Featured Plus and Pro Pack upgrades.

Featured Plus allows your listing to precede all regular listings in a category. In addition, it appears in the list with regular items according to its ending time.

Pro Pack upgrade includes several upgrades: title in bold letters, a border around the title, a small image, a colored background, Gallery Featured, and Featured Plus, providing maximum exposure.

SIGN UP FOR A MERCHANT PAYPAL ACCOUNT

Remember, eBay buyers are preconditioned to using PayPal.

- Go to www.paypal.com.
- Click the Sign Up button at the top.
- On the next screen, fill in the fields for the Merchant Account.
- Hit Submit.

When a buyer makes a payment through PayPal, PayPal will notify you by e-mail. Go to your PayPal account when you are ready to transfer funds to your bank account or to have PayPal send you a check.

VENDIO.COM GALLERY

www.vendio.com offers an automatically inserted, impossible-to-ignore, animated gallery of thumbnails of your items that will appear in your descriptions. Though many successful sellers use eBay's extra promotions instead, my sales increased when I added the Vendio feature. Browsers simply click on the thumbnail of the work they like and are taken directly to that auction listing. The monthly fee is a very reasonable $2.95.

As you become familiar with the listing process and as you study other artists' auctions, you will probably want to create more eye-appealing auctions. Though eBay's Sell Item form now allows sellers to prepare a description with a "What You See Is What You Get" process, knowing a little about HTML can be helpful in fine-tuning your description. Here's a short and simple definition of HTML.

HTML - HYPER TEXT MARKKUP LANGUAGE

HTML is the coding language used to create web pages for use on the Internet. It consists of commands enclosed in brackets, <XXX>. The most useful HTML codes are:

<p>	begin paragraph
 	go to next line
<center>	begin centering text or image
</center>	stop centering text
	begin bold text
	stop bold text
	insert an image
link text	link to another web page

TUTORIALS

▸ www.pages.ebay.aol.com/help/sellerguide/selling-html.html

▸ www.echoecho.com/html.htm

▸ www.webmonkey.com/webmonkey/reference/html_cheatsheet

ABOUT ME AND MY EBAY WORLD PAGE

Each seller—you!—on eBay has (1) space on the eBay site, (2) an About Me page and (3) a My eBay World page, on which he can provide more detailed information and links to other sites. In fact, whereas links to a personal web site or e-mail list subscription service are prohibited within auction descriptions, the rules are much more flexible on examples (2) and (3) noted above. Study other sellers' About Me or My eBay World pages for more ideas. You are trying to make yourself more credible, so you might want to include:

▸ a picture

▸ study, credits and awards

▸ a link to your web site

▸ a link to an article about you on a newspaper's or magazine's web site

▸ a sign-up box if you use an e-mail list-management service

DRESS UP YOUR LISTINGS

LISTING STRATEGY

Sellers on eBay have used each of the following strategies successfully. Sometimes, the best approach is to use some of each, to keep buyers' interest. Experiment and compare the results.

▸ Set the starting bid above your minimum price and reduce it in any repeat auctions.

▸ Enter a very low starting bid, and set the reserve amount as your minimum price. This works best if your items are priced very low so the reserve is reached quickly.

▸ Set a low starting bid with no reserve. Doing this on a few of your auctions will encourage interest in all of your listings.

▸ Set the starting bid at your minimum and add the Buy It Now option.

EBAY STORE

After you have 20 positive feedbacks, eBay allows you to open an eBay Store. I recommend you do this. Most artists use their stores to list high-end or unsold auctioned artwork. A small monthly fee, $15.95, is charged – much less than the cost of listing the artworks separately as auctions. However, you must use strategies like mine (see previous My Current Strategy box) with a store because it will not produce enough sales on its own.

Though eBay Store listings do not show up in all auction search results, they are shown on the seller list if a buyer clicks on that link on the description page. eBay Store listings cost much less (about 13 cents for a basic listing with Gallery) and run longer – up to 30 days—and can be listed as Good Till Canceled (see page 110) to automatically renew until sold. The eBay commissions, however, are slightly higher.

▸ To open your store, go to the site map and select eBay Stores under Web Stores.

▸ Be sure to pack your store listing title with those golden search words, or keywords, just as you do for auctions. Establish store categories using some of those words that produce good search results when you set up your store. Some of my categories are Plein Air Landscapes, Impressionist Florals, Realist Seascapes, etc.

eBay.com and eBayStores. com are interconnected sites, two formats that eBay uses to present items to buyers.

ADVANCED STRATEGIES

eBay Listing Formats

eBay offers several ways for eBay users to purchase items. Use the appropriate listing formats to develop the strategy that works best for you.

- **Auction** – The most common format; these get the most hits.

- **Fixed Price** – Similar to the auction format, but the seller sets a fixed price and the buyer may purchase immediately. (This format is not as useful as Buy It Now or Store listings.)

- **Store** – Items may be listed very economically at a fixed price (see more below)

- **Best Offer** – an option for eBay Store listings that allows the seller to show a purchase price but receive offers that can be accepted or declined.

Days not to list

Be aware of any upcoming holidays and special events before you list on eBay. Do not start a listing that will end on a major holiday: Easter, Christmas, Mother's Day, Thanksgiving. Surprisingly, Super Bowl Sunday is a good day for sales. Do not list heavily the two weeks before Christmas, or the two weeks before quarterly taxes are due (April 15, July 15, October 15, and January 15). Other events, such as the Olympics, or a national election, will cut into sales.

Plan promotional weeks

Several times a year, list a special group of work and e-mail the people on your e-mail list about it. Some ideas for promotion are "New Works," "Best Paintings Week," "Equine Week," "Portrait Week." Also, include those words in your auction titles or subtitles to attract attention.

Your e-mail list of patrons

As you gather e-mail addresses of buyers on eBay and others who contact you about your work, assemble a list, categorizing it by subject matter of interest, medium, etc. E-mail these people from time to time to thank them for their interest, inform them of promotional weeks, convey holiday greetings, tell them of other art shows and competitions in which you participate, or new work on your web site.

Be sure that you have each bidder's permission to include them on your list. Do not overuse this list or eBay may consider it spamming. Include instructions about how to unsubscribe from the list by including a statement such as, "If you prefer to not be on our e-mail list, hit 'reply' and type 'remove.'" This will protect you in the event of such accusations. Giving it a friendly tone should avoid most trouble.

Your collection of e-mail names can multiply your sales. It is easier to sell to repeat customers than acquire a new one.. Suggest that anyone receiving the e-mail is free to forward it to anyone they think might enjoy your work. That sentence works; I've sold paintings using it!

E-mail list management services such as www.constantcontact.com and www.listmailpro.com offer ways for collectors to subscribe and unsubscribe to your e-mail list automatically without your involvement. They also offer features that let you design effective e-mail campaigns and schedule their deployment.

E-MAIL BLASTS

Consider using www.constantcontact.com, www.listmailpro.com or the free www.bravenet.com or www.marketingartist.com list management services. Using a management service will save considerable time maintaining your list. They offer a "sign-up logo image" that you can place on your About Me or My eBay World page, your web site or your blog. (This sign-up logo image is not allowed in your auction description.)

ADVERTISE

Even small classified ads in collectors' magazines are remarkably effective. Coordinate these with your promotional weeks. Also consider magazines related to the subject of your art. If you do waterfowl, place ads in hunting magazines, environmental magazines, etc. If you do aviation art, place ads in flying magazines, military aircraft magazines, antique and experimental aircraft magazines, etc. Send postcards to your current mailing list announcing that your work is available on eBay. Note that the best way to search for your work is by entering that short form of your name (which you found by the research you did) in any eBay search box. Give your Seller ID also.

UNDER-PROMISE, OVER-DELIVER, AND REVERSE THE RISK

These are important concepts for selling on eBay. Bidders, especially those who are new to eBay, feel they are taking a risk. They do not know you and have heard horror stories about the Internet. Do not make claims that you cannot deliver!

Add something to each shipped order that the buyer did not expect—a few note cards, a small print. Even reprints of articles or leftover invitations to shows with images of your artwork are well received.

INTERNATIONAL SALES

Selling internationally can be exciting. My work has traveled from California to Canada, Germany, Brazil, England, and France. I have a great repeat buyer in Paris.

The process of shipping internationally is fairly standard, though the charges vary from country to country. I use Global Priority Mail to keep cost down and cut travel time. I've found that the less time spent in transit, the less chance of loss or damage.

- ▸ Always buy insurance.

- ▸ You must fill out a customs form.

- ▸ Never comply with a buyer's request to mark the shipment as a "gift."

NETWORK WITH OTHER EBAY ARTISTS AND SELLERS

There's strength in numbers! Have you ever noticed that communities that have a gallery district where there are multiple galleries are more vital than those whose galleries are scattered? Take this lesson online by trading experiences, ideas, and technical tips with other artists who are selling on eBay.

To find the appropriate groups on eBay, go to Community at the top of any eBay page and look for the art discussion groups such as Artist Success Strategies and Marketing Tips. You can also try www.groups.yahoo.com.

Good Till Cancelled – an option for eBay Store listings that allows the listing to renew automatically after the 30-day listing period expires.

MY CURRENT STRATEGY FOR EBAY AND ONLINE SALES

- Offer new work to e-mail list before it is listed on eBay.

ON EBAY

- If not sold through the e-mail list, list new work under $200 as a seven-day eBay auction without a reserve. List in two categories. Add Featured Plus or ProPack upgrade. Extend to 10 days, if necessary.
- If new work is over $200, list in eBay Store as Good Till Cancelled.
- On any day without a new work's auction starting: List a repeat seven-day auction of work under $200 or list a repeat seven-day auction with a very low starting bid and no reserve.
- Keep at least two of these auctions going at all times.
- Extend auctions to 10 days, if necessary.
- List gallery work in eBay Store at full gallery retail price as Good Till Cancelled and with a Best Offer option.
- Subscribe to www.vendio.com gallery.

OTHER ACTIVITIES

- Use an e-mail management service and build my e-mail list at every opportunity.
- Maintain my web site.
- Maintain my blog, since search engines love blogs.
- Have e-mail sign-up links wherever I can.

TIPS

→ Listing in multiple categories produces more hits on any listing, whether or not you have upgraded to Featured Plus or ProPack. Choose the appropriate fine-art subcategory and a category that relates to the subject matter, such as Home and Garden, Equine, Fishing Equipment, etc.

→ Avoid the Self-Representing Artists subcategory because the average winning bid is lower than in the other art subcategories.

Second Chance Offer – If a winning bidder decides not to complete the purchase, you can offer the artwork to the next highest bidder through eBay. This feature is also useful if the bids do not reach the reserve amount, and you are willing to accept near-reserve bid.

→ When you have bids on an auction, e-mail the bidders and tell them the reserve amount during the last 24 hours of the auction if the reserve has not been met.

→ If the final bid is close enough to the reserve, use the Second Chance Offer. You will probably save that much by not having to list it again. To use this feature, look in the drop-down list to the right of the auction title in the Unsold Auction section on the My eBay/All Selling page.

→ If an auction doesn't get a bid after a few days, change the title, change the subtitle, try a slightly different starting bid, etc. Keep changing things until you get a bid and cannot edit anymore.

→ Send an e-mail thanking the bidders. Suggest another piece they might like and mention your shipping discount on multiple purchases.

→ Identify what subjects and sizes sell best for you on eBay. I find that florals, horses, and plein air landscapes sell best for me. My portraits do not sell for high bids, but other portrait sellers thrive.

→ Using as many free and low-cost services as possible is essential to keeping costs to a minimum. eBay now offers many more management features for sellers, like My eBay and My Messages, than they did when the first edition of this book appeared.

→ Use a photo hosting sites like www.photobucket.com.

→ www.bravenet.com offers many free services and tools like e-mail list management, photo storage, ways to promote your web site and eBay listings, e-mail forms, and more.

→ www.vendio.com and other auction management sites have a host of tools, some of which are free. (See Resources.)

→ Continue to study other art listings for ideas and watch the discussion and announcement boards.

→ Make prudent changes and test the results by keeping records of hits, numbers of bids, ending bids, etc. If you have an eBay Store, you can subscribe to eBay Marketplace Research. It is well worth the one-time usage fee of $2.99 or the $9.99 monthly charge.

It goes without saying: Never try to sell an artwork off of eBay to someone who has found it on eBay. eBay has offered us this incredible opportunity and deserves fair treatment by sellers.

→ Read Category Tips for the art category: Click on Site Map at the top of any eBay page. Under Selling Activities, click on See All Selling Activities. On that page, choose Category Tips under Choose a Topic. It is important to keep in mind that eBay is a fluid medium. Be open to allowing your listing strategy to evolve. Changes on eBay and outside forces—economic, seasonal, social, and political—will affect sales.

TITLE SEARCH WORDS

It is essential to saturate your auction title with search words and keywords. Use all 55 spaces to corral prospects.

CONSISTENT LISTINGS

Group auctions over consecutive days. If you run out of funds or stock, have one regular auction running so shoppers will know that you are still in business.

REASONABLE RESERVE OR STARTING BID

▸ Set the reserve or starting bid at one-third of your brick-and-mortar gallery retail price.

▸ Have at least one piece to list each day for less than $100 to attract bidders.

▸ Artworks just under $200 sell consistently, too, and lead buyers to your higher-priced work.

CAREFUL USE OF UPGRADES

Upgrades place your listings nearer the top of the category lists and search results. They cause more bidders to view your listings producing more bids; bids compound into more bids and higher ending bids.

▸ The Gallery upgrade is a must for art.

▸ Have some Featured Plus ($19.95) auctions when you have multiple auctions going. Some of the most successful artists/sellers use this upgrade all of the time, but you must watch your overall profit margin carefully.

▸ The ProPack upgrade ($29.95) will get even more hits and bids. I often use this for new work. I have more hits and more auctions that meet or exceed my reserve when I list all new work with ProPack, even though such listings can cost up to $45. These also drive traffic to my repeat auctions that are not upgraded and my eBay Store listings.

▸ Value Pack (65¢) includes gallery, subtitle, and listing designer—one of eBay's pre-designed descriptions.

CULTIVATING AND USING YOUR PATRON E-MAIL LIST

Use your e-mail list to get repeat customers to your eBay listings.

▸ Before you list a new auction on eBay, offer it to your previous collectors.

▸ Relist the artwork with a Buy It Now option at a time when it is convenient for the buyer to be online and have him go through the buying process.

THE FIVE MOST IMPORTANT FACTORS

Understanding these factors will create a successful art business for you on eBay.

TIMESAVERS

By far, the most useful feature for eBay sellers is the My eBay/All Selling page. I have referred to it many times throughout this chapter. It has automated many labor-intensive activities. On this page sellers can:

- List a new artwork by clicking on Sell Similar beside a listing title. All you need to do is change the specifics that apply to the new artwork.

- Check e-mail messages from eBay or buyers.

- Review and edit scheduled listings.

- View activity on current listings, revise or add to the item description, list a similar item, end the listing, or create new listings.

- Track post-auction activities of sold pieces.

- Revise and relist unsold listings and make Second Chance offers.

My eBay/All Selling page also provides quick access links to other useful features whose links are in the left-hand column and at the bottom of the page. For example, you can access Your Favorites list for eBay, similar to Favorites or Bookmarks. You can also access and edit your account information, manage your eBay Store, and see Marketplace Research (if you subscribe).

Many post-auction processes of contacting buyers and collecting payment are now automated. The time saved on those activities is considerable. Once you have a Master Auction Description in place and can use the Sell Similar form on the My eBay/All Selling page, your auction preparation will take only minutes.

RESOURCES

Continuous education is a must in any venture. After you have started your auctions and have absorbed what's in this chapter, start educating yourself more so you can be ahead of the competition.

EBAY RESOURCES

eBay discussion boards – Here, eBay users post ideas and comments. They are packed with information on everything related to eBay. To explore these, click on Community at the top of any eBay page. Again, participate at your own risk. Sometimes they can become quite uncivilized.

Site map – There is a site-map link at the top of any eBay page that has a comprehensive list of links that take you quickly to the information you are looking for. If you do not see what you need, look under Selling Activities, Selling Resources, or Selling Tools. Click the last link under each of those headings that says "See all…."

Contact eBay – If you cannot find the information you need in eBay Help or elsewhere on the site, you can contact eBay to ask your question by going to Help at the top of any eBay page and then clicking on Contact Us in the left column.

Seller guide – Find information here about selling in the art category. Go to: www.pages.ebay.com/newsletter/art_sellersedge.html. This is a great help, packed with lots of info.

eBay university – www.pages.ebay.com/university/index.html

Tools to assist you on eBay – www.pages.ebay.com/sell/tools.html

OTHER WEB SITES

Again, many companies on the Internet offer services to auction sellers. Most are enticing and have attractive features, but you will lose much of your profit if you sign up for many of these. Monthly fees add up fast, so be selective. Still, some can increase your sales potential.

www.vendio.com - I recommend the Gallery service, as discussed previously.

www.viewtracker.com - If you are the type who can look at data and draw effective conclusions, www.viewtracker.com can give you the information you need. They report what site and link led the viewer to your auction. Such information can help you decide what categories are most effective for you, what outside web sites or blogs bring viewers to your listings, whether your web site links are doing their job, etc.

www.auctionbytes.com - Sign up for their free newsletter. It will keep you up-to-date on eBay announcements, such as free listing days, and acquaint you with other related news and scuttlebutt about online auctions.

www.auctionriches.com - Offers very helpful information as well as e-books, many of which are free. Highly recommended once you have mastered the basics.

www.susanfgreaves.com - Click on Especially for Artists in the menu on the left. You will find more information to help you sell your artwork on eBay and on the Internet. There are great ideas for promoting your work online and it's all free.

www.artmarketing.com – Don't forget Constance Smith's comprehensive marketing services that complement this book so beautifully!

ONE RULE YOU MUST NOT VIOLATE

Never answer a rude or unfair comment in anger.

eBay users are sometime quick to misunderstand, thinking a seller might take advantage of them. When such a comment comes, wait until your anger passes and then answer it with reason, fairness and consideration. Almost always, the problem will be solved without negative consequences. (There will be a few malicious comments from non-bidders that you should dump immediately without responding and force yourself to erase from your psyche. These will be few and far between, I promise!)

RECOMMENDED READING

eBay for Dummies by Roland Woerner and others

The Official eBay Guide by Era Fisher Kaiser and Michael B. Kaiser

Online Auctions @ eBay by Dennis L Price

Starting an eBay Business for Dummies by Marsha Collier

Chapter 8

Search and You Shall Find

Sites to browse

Do what you can, with what you have, right where you are.
Theodore Roosevelt

WWW.ARTMARKETING.COM/LINKS

At this site you can access about 20 various categories of art-related links:

Art search engines	Auctions	Books, art-related
Consultants/reps	Copyright info	Framing
Galleries	Grants	Insurance
Jobs	Legal info	Libraries, art
Licensing agents	Lighting	Magazines, newsletters
Museums	Online galleries	Organizations, art
Printers	Private art studios	Publishers
Residencies	Resources	Shipping
Slide services	Software	Supplies and catalogs
Taxes	Theft and fraud	Travel

ACCOUNTING SITES

akasii
irs.gov
smartmoney
taxguide.completetax

APPRAISERS

appraiseit.net
appraisers.org
appraisersassoc.org
artbusiness.com/appsum.html
artdealers.org/appraisals
artworth
chicagoappraisers
fineartappraiser
pada.net/services.html

ART NEWS

artknowledgenews
artnet
artnews
art-of-the-day
artsjournal
theartnewspaper

BARTERING

artofbarter
ctebarter
intagio
itex
thinkingaboutart.blogs.com/art
tribes.tribe.net/barterforart

BOOKS

abcartbookscanada
allbooks4less
allworth
amazon
artbooks
artmarketing
barnesandnoble
booklocker
booksamillion
bookstorming
borders
merrellpublishers
nyschoolpress
powells
ursusbooks

BUSINESS

artmarketing
artbusiness
bizartinfo
marketingartist

COMPETITION LISTINGS

artdeadlines
artshow
nyfa.org

CONSULTANTS

artbizcoach
artistscube

COPYRIGHT FORMS

artmarketing.com/artoffice/formva.html
loc.gov/copyright/circs

FINE ART REPRODUCTIONS

art
artrepublic
artseek
barewalls
beyondthewall
clicart

FUNDING AND GRANTS

fdncenter.org
arts.endow.gov
midatlanticarts.orgnasaa-arts.org

GALLERIES

art4business
collectfineart
latinarte
nextmonet
neoimages
paintingsdirect
photocollect

INSURANCE

fineartguy
fracturedatlast.org

JOBS

westaf.org

LEGAL SITES

artistic-law
artslaw.org
clemcheng
clickandcopyright
danziger
erklaw
feldman-law
jjkaufman
starvingartistslaw
vlany.org
vsaarts.org
wcclaw

MUSEUMS

icom.museum/vlmp

ORGANIZATIONS

aia.org
aiga.org
artdealers.org
artistresource.org
collegeart.org
fada
fota
gag.org
nationalwca
naea-reston.org
watercolor-online
wsworkshop.org
ylem.org

PUBLICATIONS

absolutearts
airbrushaction
american-artist
art-of-the-day
artaccess
artaffairs
artbusinessnews
artcalendar
artdaily
artfind.co.nz
artfocus
artforum
artistsmagazine
artkrush
artnet
artnews
artnexus
artsmanagement.net
artupdate
artweek
burlington.org.uk
coagula
contemporary-magazine
digizine
international-artist
jca-online
latinarte
newsgrist
painterskeys
shutterbug
stateart.com.au
sunshineartist
theartnewspaper
theblowup

PUBLICITY

publicityhound

RESEARCH

artlex
findartinfobank

RESIDENCIES

djerassi.org

SCULPTURE

artnut
sculptor.org
sculpture.org

SHIPPING SERVICES

fedex
fineartship
ups
usps

SUPPLIES

aardvarkart
artistsupplies
artplace
artsuppliesdirect
cheapjoes
daler-rowney
danielsmith
dickblick
discountart
fineartstore
frameandart
islandblue
jerryscatalog
mcintoshart
meininger
misterart
nycentralart
saxarts
studioartshop
texasart
tridentart
utrecht
whslartframe

TRADE SHOWS

artexpos
surtex

TRAVEL

artmarketing.com/artlocales
paris.org

MISCELLANEOUS SITES

artlibrary - Over three million images

arts4allpeople.org -The Wallace Reader's Digest Fund and an advisory board of arts leaders and funding partners have developed a website for individuals and organizations committed to promoting new ideas and practices in the arts. The site features success stories, an online library of practical research, resources and discussion boards.

chihuly - This site is one of the best ones I've seen by an artist. He has spent bundles on it and probably has his own web master (if not two!). He sells his artwork to museums and top private collecctors— a big name now in the artworld. His videos are many and great.

jimmott - Jim has been traveling around the country painting and selling his art. He has a unique and interesting tale.

rejectioncollection - The artist's online source for misery, commiseration and rejection letters

scraphouse - A project on public architecture

streetstudio - A pair of innovative photographers walk the streets of New York City (they started long before 9/11) with the intent of photographing every person in the city of eight million. So far they are up to 20,000.

vdb.org - Video Data Bank carries over 1500 titles of video tapes by and about contemporary American artists.

internic - Here is the spot where you can complain about a site, make a comment about the content of a site, or complain about a spam sender not taking you off their list

superpages.com/yp4.superpages.com - Search an area within a 5- to 100-mile radius for businesses: galleries, architects, interior designers, frame shops, etc.

ipl.org/ref/RR/Internet Public Library - Ready Reference Collection provides links to relevant data on numerous disciplines.

usps.com/ncsc/lookups/lookup_zip+4.html - A quick and easy way to look up zip codes

Italic type = Publications and videos

Bold type = Companies, shows and organizations

LOCAL PROMO MAILING LISTS

Promote your open studio or exhibition by inviting local art professionals.
Our local promotion lists include the following eight categories:

Art publishers * **Galleries** * **Consultants, reps and dealers** * **Architects**
Interior designers * **Museum curators** * **Corporations collecting art** * **College gallery directors**

Some examples of counts follow. More geographic areas are listed online at www.artmarketing.com. Call or e-mail for a quote for your specific needs.

California	2700 names	$200
Northern California	1350 names	$115
Southern California	1350 names	$115
San Diego	200 names	$50
Los Angeles	525 names	$75
San Francisco Bay Area	725 names	$85
San Francisco	350 names	$55
New York City	1200 names	$115
New England	1000 names	$100
Boston	210 names	$50
Chicago	300 names	$50
Illinois	500 names	$65
Florida	600 names	$75
Georgia	245 names	$50
Hawaii	90 names	$40
Michigan	300 names	$55
Mid-Atlantic	650 names	$80
Minnesota	225 names	$50
New Jersey	350 names	$55
New Mexico	350 names	$55
Ohio	250 names	$50
Oregon	275 names	$50
Seattle	225 names	$50
Texas	600 names	$70

ArtNetwork
PO Box 1360, Nevada City, CA 95959-1360 530·470·0862 800·383·0677 www.artmarketing.com

ART WORLD MAILING LISTS

Artists (46,000 names) $100 per 1000

Architects (650 names) $60

Art Councils (640 names) . $60

Art Museums (1000 names) . $85

Art Museum Store Buyers (550 names) $75

Art Organizations (1800 names) . $110

Art Publications (700 names) . $75

Art Publishers (1150 names) . $95

Art Supply Stores (800 names) . $65

Book Publishers (325 names) . $50

Calendar Publishers (100 names) . $50

College Art Departments (2500 names) $130

Corporate Art Consultants (175 names) $50

Corporations Collecting Art (475 names) $60

Corporations Collecting Photography (125 names) $50

Galleries (5500 nationwide names) . $400

Galleries Carrying Photography (320 names) $50

Galleries/New York (750 names) (more city/state selections online) $75

Greeting Card Publishers (640 names) $70

Greeting Card Reps (300 names). $50

Interior Designers (600 names) . $55

Licensing Contacts (200 names) . $50

Public Libraries (1500 names) . $110

Reps, Consultants, Dealers, Brokers (1600 names) . $125

All lists can be rented for onetime use and may not be copied, duplicated or reproduced in any form. Lists have been seeded to detect unauthorized usage. Reorder of same lists within a 12-month period qualifies for 25% discount. Lists cannot be returned or exchanged.

Formats/Coding
All domestic names are provided in zip code sequence on three-up pressure-sensitive—peel-and-stick—labels (these are not e-mail lists).

Shipping
Please allow one week for processing your order once your payment has been received. Lists are then sent Priority Mail and take an additional 2-4 days. Orders sent without shipping costs will be delayed. Shipping is $5 per order.

Guarantee
Each list is guaranteed 95% deliverable. We will refund 39¢ per piece for undeliverable mail in excess of 5% if returned to us within 90 days of order. We mail to each company/person on our list a minimum of once per year. Our business thrives on responses to our mailings, so we keep our lists as up-to-date and clean as we possibly can.

ArtNetwork
PO Box 1360, Nevada City, CA 95959-1360 530·470·0862 800·383·0677 www.artmarketing.com

ONLINE GALLERY

NOT READY TO SPEND HUNDREDS OF DOLLARS TO HAVE A WEB SITE BUILT?

Take advantage of ArtNetwork's low-cost, high-exposure home pages. Our two-year plan is economical and allows you to have a professional "spot" on the web to call home.

Our 20 years' experience within the art world has made our site popular among thousands of art professionals. We contact these professionals annually via direct mail—they know us and the quality of artists we work with.

A home page with ArtNetwork will include five reproductions of your artwork (you can get a double page of 10 pieces if you like). Each artwork clicks onto an enlarged rendition, approximately three times the size. Two hundred words of copy (whatever you want to say) are also allowed on your main page, as in above layout.

Artmarketing.com receives between 400,000-500,000 hits per month—an average of 1500 users a day (and rising each quarter). The gallery is the second-most visited area on our site.

- We pay for clicks on Google for a variety of art genres: abstract, equine, nature, environmental, whimsical and many more.

- We publicize our site to art publishers, gallery owners, museum curators, consultants, architects, interior designers and more! Your home page on our site will be seen by important members of the art world.

TO SHOWCASE YOUR WORK ONLINE, GO TO WWW.ARTMARKETING.COM/ADS

ArtNetwork
PO Box 1360, Nevada City, CA 95959-1360 530·470·0862 800·383·0677 www.artmarketing.com

BUSINESS BOOKS FOR ARTISTS

Licensing Art 101: Selling Reproduction Rights for Profit

Expose your artwork to potential clients in the art publishing and licensing industry. You will learn how to deal with this vast marketplace and how to increase your income by licensing your art. Contains names, addresses, telephone numbers and web sites of licensing professionals and agents.

Negotiating fees * How to approach various markets * Targeting your presentation
Trade shows * Licensing agents * Protecting your rights

Selling Art 101: The Art of Creative Selling

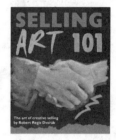

This book teaches artists, art representatives and gallery sales personnel powerful and effective selling methods. It provides easy-to-approach techniques that will save years of frustration. The information in this book, combined with the right attitude, will take sales to new heights.

Closing secrets * Getting referrals * Telephone techniques * Prospecting clients
14 power words * Studio selling * How to use emotions * Finding and keeping clients
Developing rapport with clients * Goal setting * Overcoming objections

Art Marketing 101, A Handbook for the Fine Artist

This comprehensive 21-chapter volume covers everything an artist needs to know to market his work successfully. Artists will learn how to avoid pitfalls, as well as identify personal roadblocks that have hindered their success in the art world.

Preparing a portfolio * Pricing work * Alternative venues for selling artwork
Taking care of legal matters * Developing a marketing plan
Publicity * Succeeding without a rep * Accounting * Secrets of successful artists

A Gallery without Walls: Selling Art in Alternative Venues

This book will lead you to a greater understanding of how to select and then reserve the best space to exhibit your work. It will also teach you how to promote your artwork on a limited budget.

The Sacred Sales Spot * Themed events * The Red Dot Syndrome
Finding alternative venues * Art Teas * Making a penny scream
Promotion on a shoestring

Art Office: 80+ Forms, Charts, Legal Documents

This book contains 80+ forms that provide artists with a wide selection of charts, sample letters, legal documents and business plans . . . all for photocopying. Organize your office's administrative and planning functions. Reduce routine paperwork and increase time for your art creation.

12-month planning calendar * Sales agreement * Form VA * Model release
Phone-zone sheet * Checklist for a juried show * Slide reference sheet
Bill of sale * Competition record * Customer-client record * Pricing worksheet

ArtNetwork
PO Box 1360, Nevada City, CA 95959-1360 530·470·0862 800·383·0677 www.artmarketing.com

WWW.ARTMARKETING.COM